SEASONS OF THE PINES

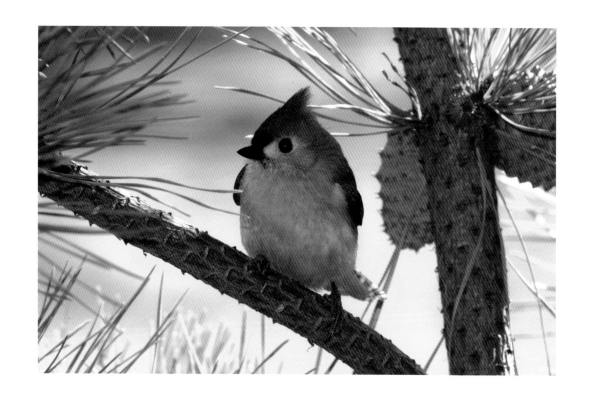

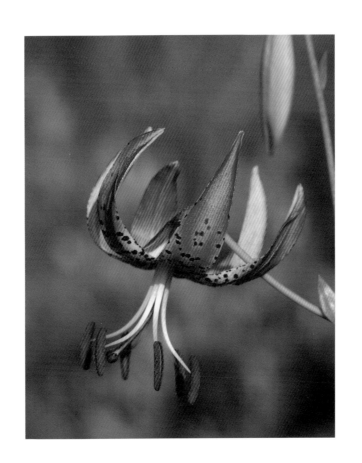

SEASONS OF THE PINES
A Photographic Tour of the New Jersey Pine Barrens

by

Bob Birdsall
Nature Photographer

Design
by
Jean Sault Birdsall

Island Publishing

Barnegat Light, New Jersey

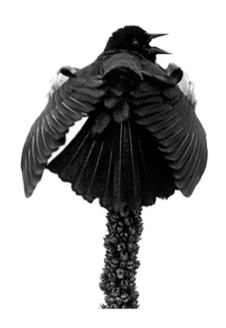

Published by Island Publishing
© 2004 Island Publishing, All Rights Reserved

Island Publishing
PO Box 267
Barnegat Light, New Jersey 08006

Printed in Hong Kong
through Bolton Associates, San Rafael, California

Distributed by Rutgers University Press
New Brunswick, New Jersey

First Edition

Library of Congress Cataloging-in-Publication Data
Birdsall, Bob.
 Seasons of the pines : a photographic tour of the New
Jersey Pine Barrens / by Bob Birdsall ; design by Jean
Sault Birdsall.-- 1st ed.
 p. cm.
ISBN 0-8135-3439-9 (hardcover : alk. paper)
1. Nature photography--New Jersey--Pine Barrens. 2.
Natural history--New Jersey--Pine Barrens. 3. Pine
Barrens (N.J.)--Pictorial works. I. Birdsall, Jean Sault.
II. Title.
 TR721.B54 2003
 779'.3'0974961--dc22
 2003022250

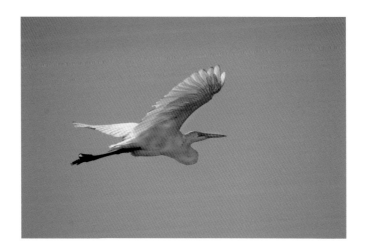

Dedication

To our grandchildren, with the hope they grow up to love and appreciate the beauty of nature

Acknowledgements

Ron Brewer for introducing me to the wonders of nature

Ted Gordon and David Birdsall for their assistance in species identification

My sons, Bobby, Gerry, David and Eddie, for years of wandering around cedar swamps looking for subjects to photograph

Alyssa and Patrick Brennan and Cindy Reilly for their editing

The staff at Wells Mills County Park, especially German Georgieff, Mickey Coen, Michele Urban and Cliff Oakley

Mike Baker, a fellow Pinelands photographer, for helping with the search for species

Don and Karen Bonica, Toms River Aviary

Jeanne Woodford and her staff at the Cedar Run Wildlife Refuge

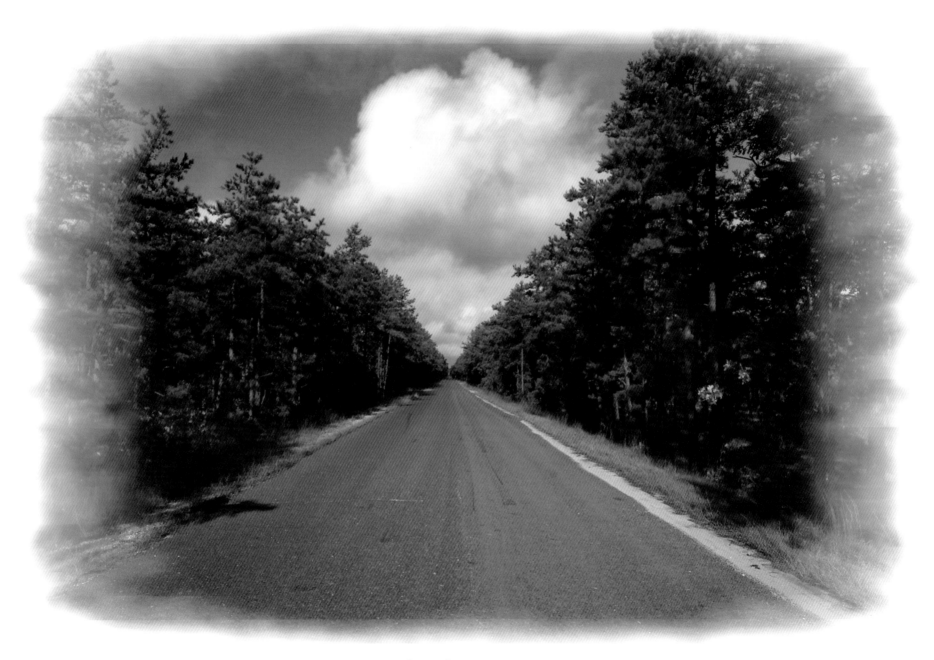

The road to "You Guess"
from the Foreword

Foreword

There is a road I know that begins in the tiny Pine Barrens town of I'll Not Say and ends, twelve miles away at the junction of You Guess. Along both sides are dark forest broken only by the occasional bog, lake and stream and it is beautiful at all seasons because the Pine Barrens differs, but is not diminished by the process of time.

I drive this road as often as expedience and fortune provide and every time I do I make a game of it. I try and navigate its length and not encounter another vehicle. That's right. Twelve miles of paved highway in the most crowded state in the Union and I throw dice with the Universe, betting that I'll have that road all to myself.

You'll bet that I lose a lot, don't you? You're wrong. The truth is I routinely win my wager and when I do lose it's only by a single car, rarely two. Open, unpeopled space is one of the two greatest gifts the Pine Barrens has to offer visitors and residents. The other is its exquisite beauty. That's what Bob Birdsall captured in this book.

I'm a New Jersey native but not a Piney by birth; born in rural Morris County (a place that doesn't exist any more). I squandered my youth catching turtles and frogs in the vernal vestiges of glacial Lake Passaic and when I got my license my explorations went for the most part north, not south, into the mountains and forests of Warren, Sussex and Passaic Counties.

It was only after I moved to Cape May to take a post with New Jersey Audubon's Cape May Bird Observatory that I came to discover the magic inherent in the Pines. Today, I live on the southern border of that ecological wonderland, counting my blessings and savoring the time I get to spend in search of…

Exquisite orchids and brilliantly patterned reptiles; seasonal wonders and scenes that shift with the season; close encounters with birds, insects, mammals…even members of our own species. Locals. Pineys! (As they pridefully describe themselves.) Resourceful people with sugar sand in their shoes and the scent of pine in their clothing.

All these things you will find in the pages of this book. Whether you live in a loft in Hoboken, a five acre ranch in Hunterdon, a garden apartment in Parsippany or a retirement community in the Pine Barrens itself, when you open this book, you become a Piney in sprit and vicarious fact.

At first I thought I would not name my favorite photos. To do so (I thought) could only do a disservice to the rest. But I changed my mind. A book, after all, is fifty percent viewer/reader; fifty percent writer/artist. The beauty of Bob Birdsall's images forced me to evoke the right and privilege of readership. So here are my favorites.

Of course I love the Tufted Titmouse on page one—a bird with eyes so baleful that a basset hound would die of envy and the Bullfrog transports me back to the frog and turtle catching days of my youth—a time when fortune and glory were within the reach of quick hands and life had no greater risk than the admonishment mothers direct toward children who come home with sodden shoes.

The cranberry harvest depicted on multiple pages is a New Jersey pageant and the Pine Barrens Stream recalls the canoe trips I used to lead for the New Jersey Audubon Society back when I was a young, journeyman naturalist.

I love fog and deer (except when I'm driving) so the buck in velvet was a photo I warmed to especially after hearing the photographer's admission that he never saw the deer standing beyond until the film was developed.

You see? There are hidden wonders everywhere! Look closely and you bind them in memory. Look askance, with eyes untrained in the sifting of wonders from a natural landscape and you'll go wanting.

But with this book, even the most untutored, stay-at-home reader, can see the wonders it would take a trained naturalist a lifetime to muster. Bob Birdsall has captured them for you. All you have to do is sit back and savor.

And then?

Well, I have a suggestion. Don't consider this book just a summary of Pine Barrens images. Think of it as a beginning—your first step on a journey to wonder and discovery. What I suggest is that you visit the Barrens for real and start harvesting your own collection of images; with camera or an open mind.

Places as wonderful as the Pine Barrens come few and far between (and they are simply too special to miss).

Pete Dunne
Vice President, Natural History Information
New Jersey Audubon

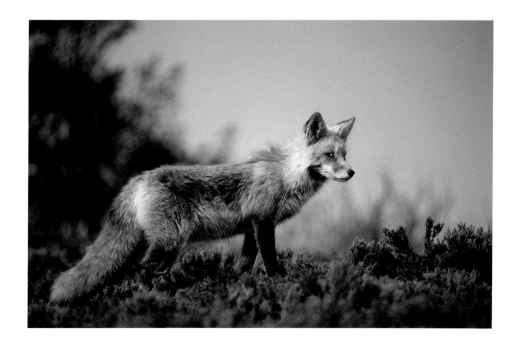

INTRODUCTION

As a young boy growing up in South Jersey over 50 years ago, my first recollections of the Pine Barrens go back to a summer scout camp in Lebanon State Forest. The days were filled swimming in Pakim Pond's cedar water and exploring the woods collecting frogs, snakes and other "critters" that encourage exploration. The nights were spent around a campfire with the counselors spinning stories about the legendary Jersey Devil, convincing us he was lurking in the dark woods and planning to pounce on us that night. Needless to say, we kept the camp fires burning all night and slept with one eye open.

During my adult years, I was fortunate enough to travel to and photograph all 50 states, Europe, Australia and live and work in Canada, Yet I've always been drawn back to the Pine Barrens of my youth. I'm the first to admit we don't have the jagged peaks of the Rocky Mountains, or the wildflower fields of the Texas Hill Country, or the white water rapids of the Colorado River, and you'll never see a grizzly bear feeding on salmon in one of our rivers. However, we do have the Forked River Mountains that open up a breathtaking vista stretching to the Atlantic Ocean, and orchids that grow here as beautiful as any flower that's ever bloomed, gentle rivers that flow through a truly pristine wilderness area, and finally an endangered, one and a half inch tree frog that has become the rallying cry for those fighting to preserve this fragile ecosystem.

Seasons of the Pines is a collection of photographs I've taken over 20 years exploring the Pine Barrens. My goal is to portray the wildlife, plant life, and scenic places with the dignity, beauty, and wonder they deserve. With the assistance of Ted Gordon, the noted Pine Barrens Botonist and historian, and of my son David Birdsall, also a Botonist, I've researched each subject to properly identify its species. Also invaluable in this research were the fine books, *A Field Guide to the Pine Barrens of New Jersey* and *Wildflowers of the Pine Barrens of New Jersey* by Howard P. Boyd.

This 1.1 million acre wilderness, designated as our country's first National Reserve, does not give up its secrets easily. It is best explored on foot or driving the countless sand roads that lead into its interior. The photographs in the *Seasons of the Pines* are presented by season, each special in its own way. I've also included a section featuring the Forsythe National Refuge. This National Wildlife Refuge, which is encompassed by the Pinelands National Reserve, is a Mecca for birders and photographers alike, and is special in any season.

 Fifty years after that scout camp, I still look forward to a day exploring and photographing in this true wilderness area (although my 4x4 makes the day a little easier). I encourage you to venture off the paved roads that slice through the Pine Barrens and experience the wonders of the little known yet very accessible area, and please, keep your eye out for the Jersey Devil. I still do!

Bob Birdsall

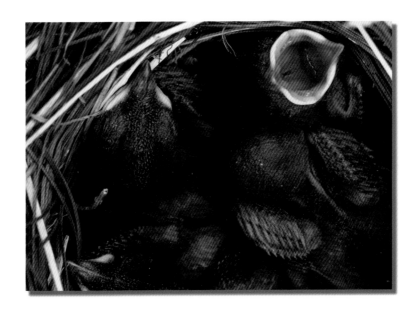

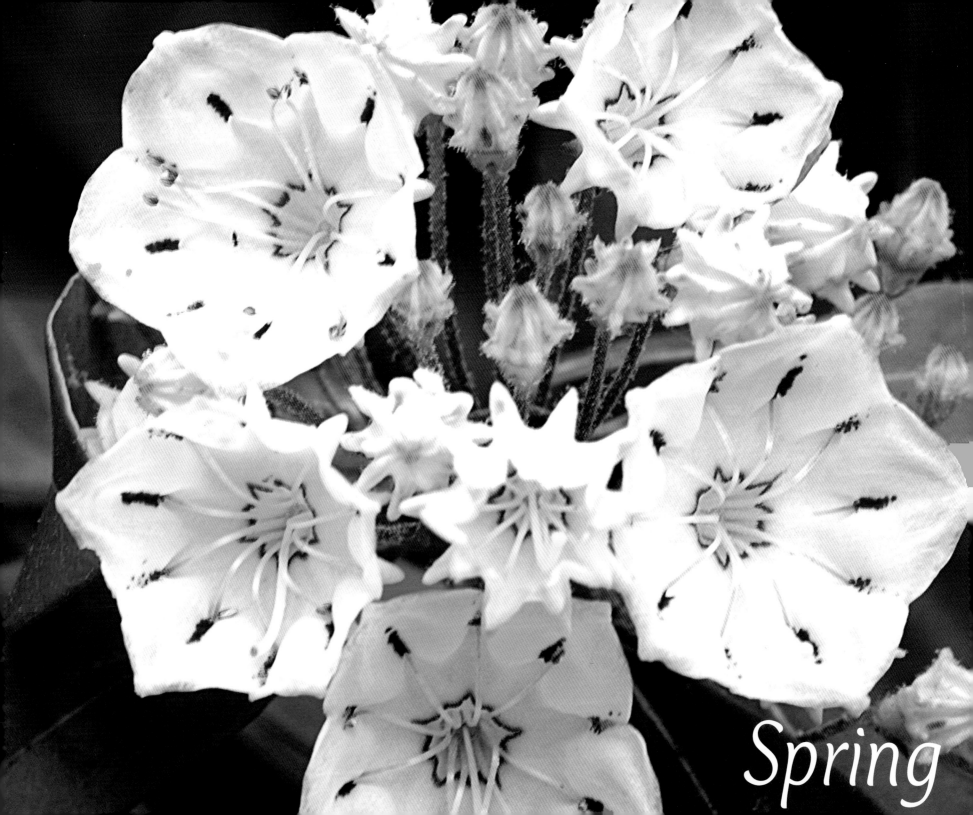

Spring

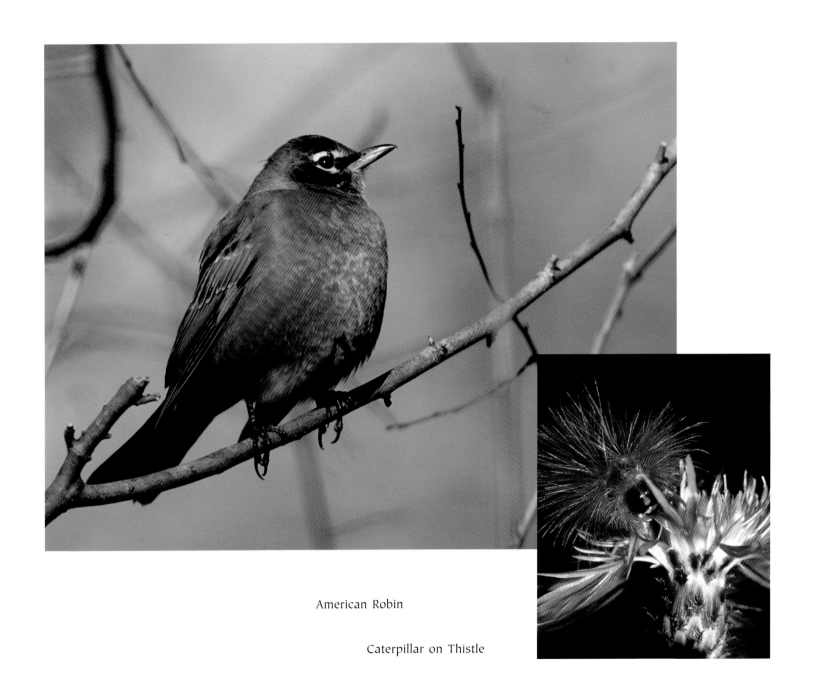

American Robin

Caterpillar on Thistle

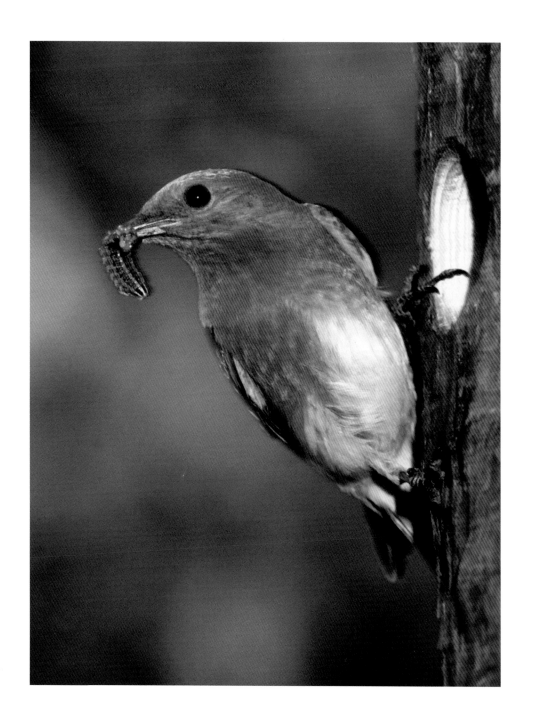

Eastern Bluebirds

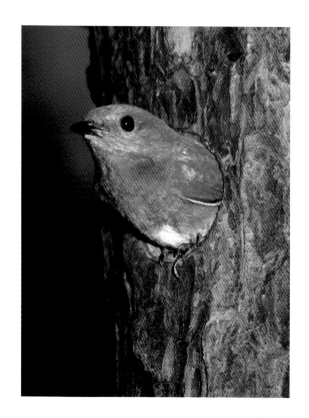

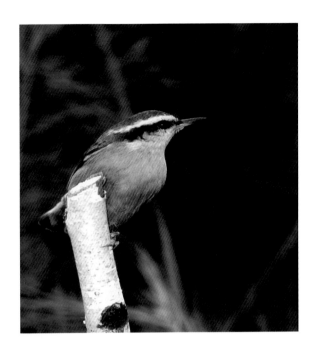

Red-breasted Nuthatch

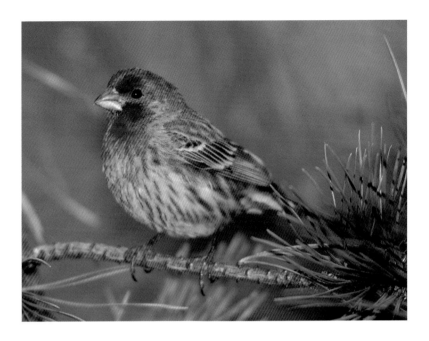

House Finch

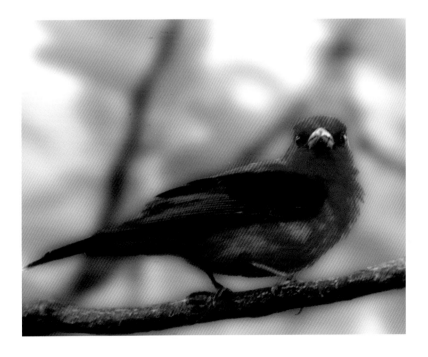

Scarlet Tanager

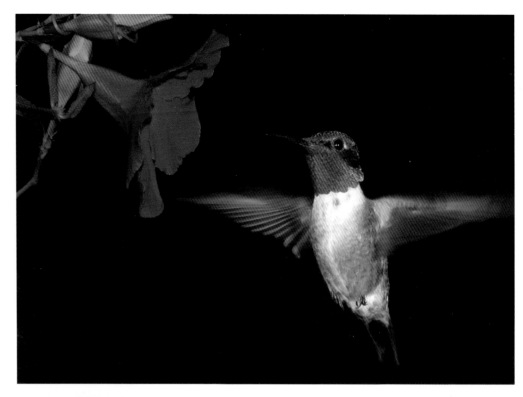

Ruby-throated Hummingbird

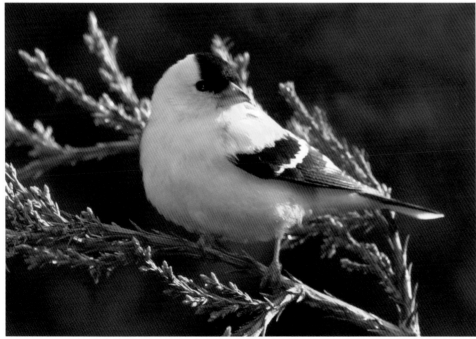

American Goldfinch

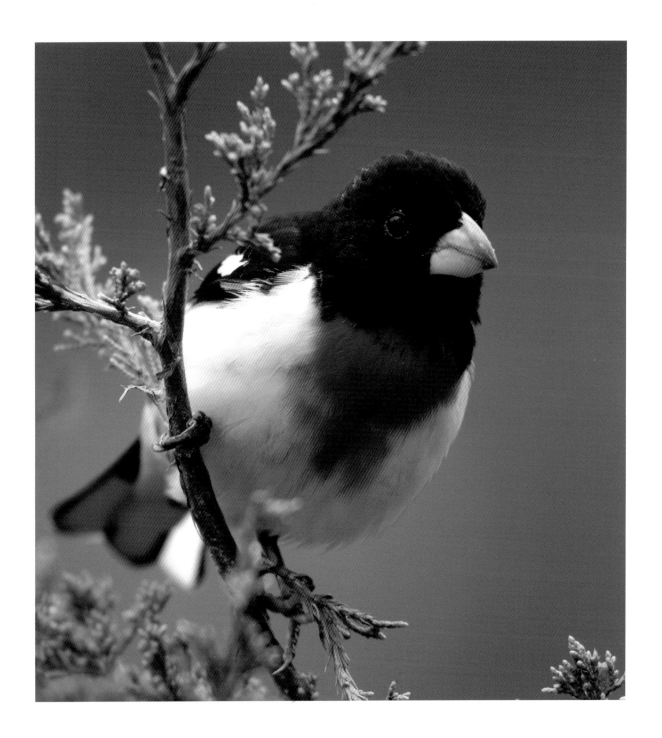

Rose-breasted Grosbeak

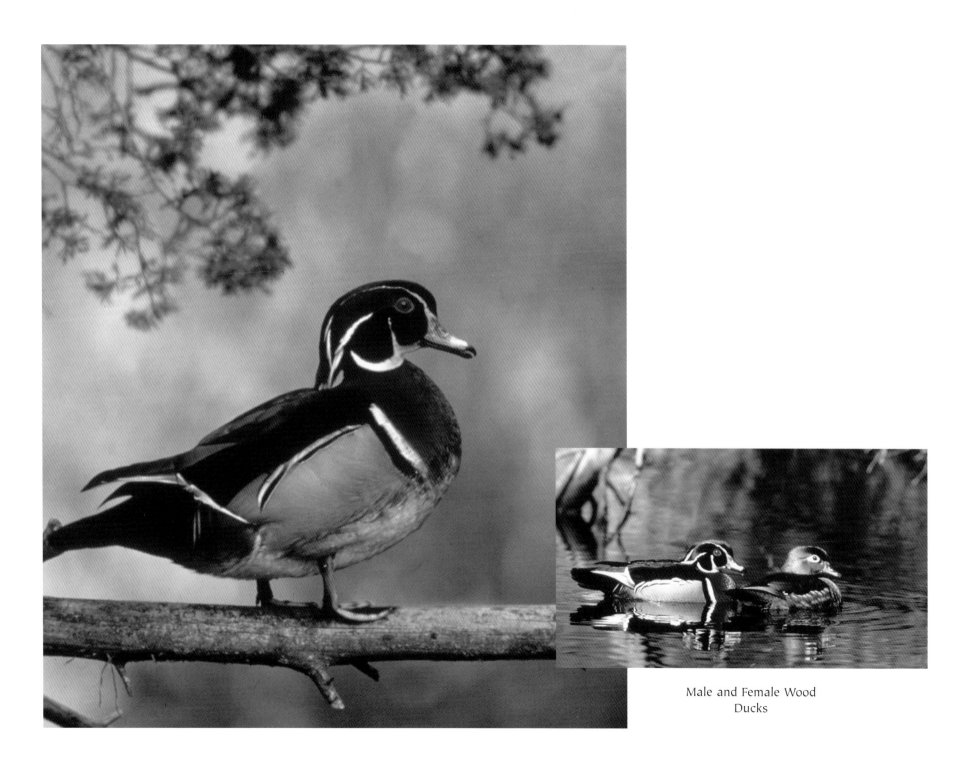

Male and Female Wood Ducks

17

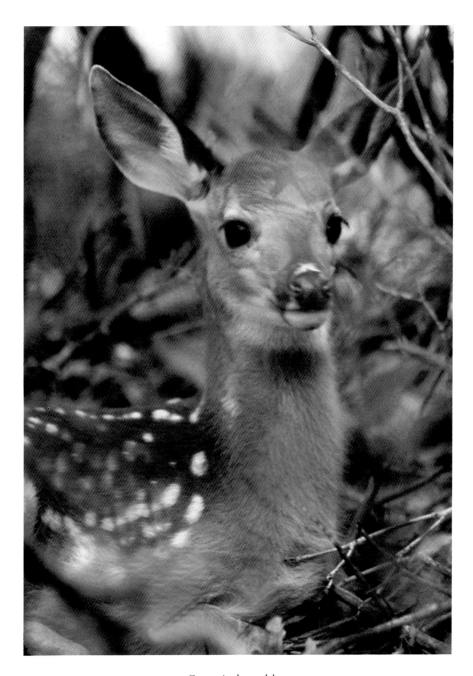

Fawn in brambles

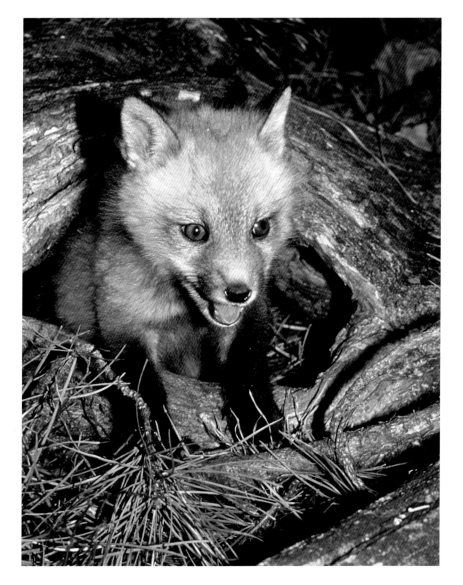

Baby Fox (Kit)

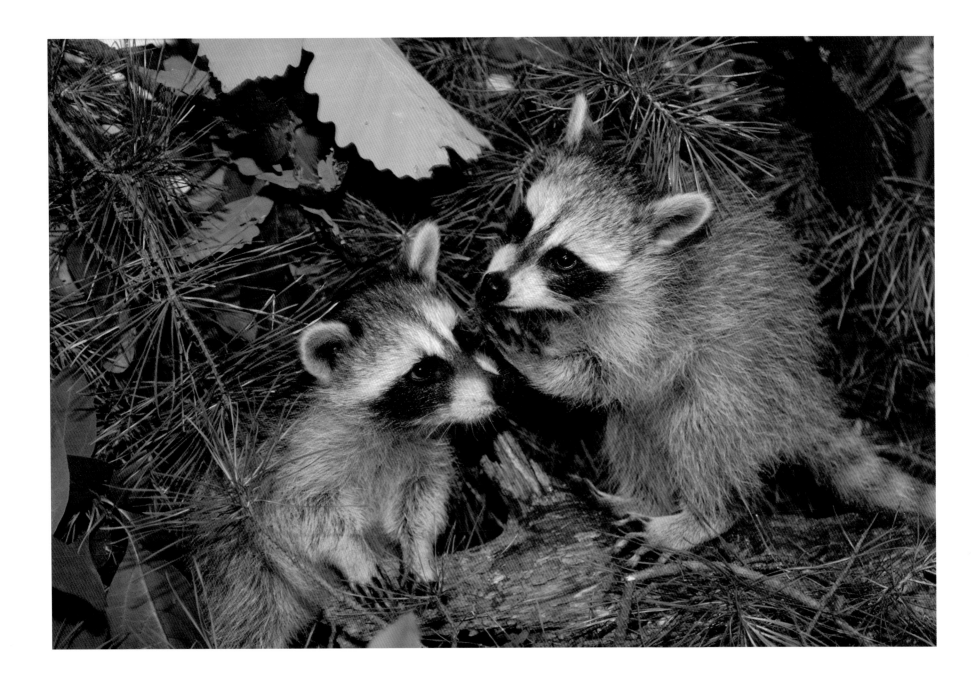

Racoon young

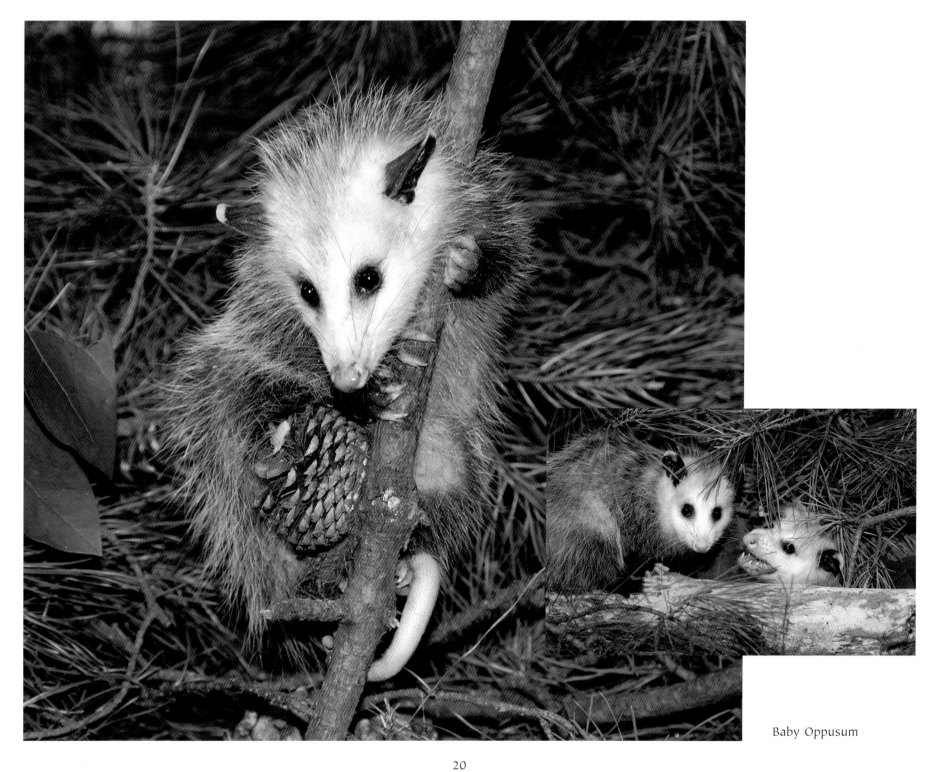

Baby Oppusum

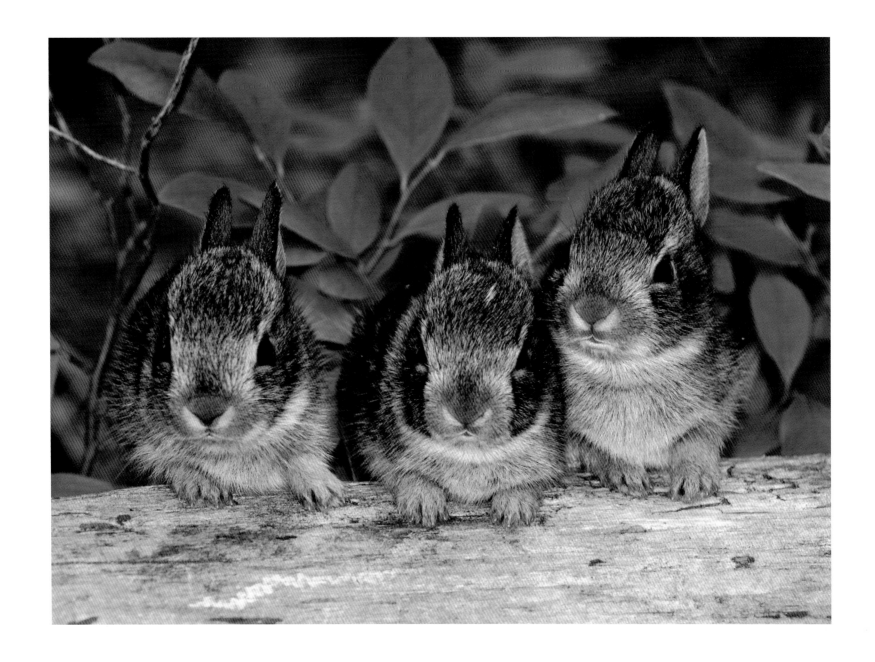

Eastern Cottontails

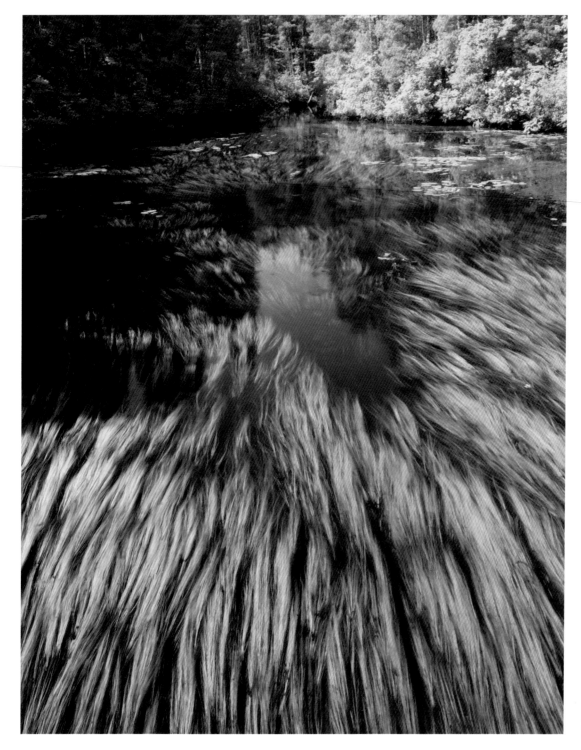

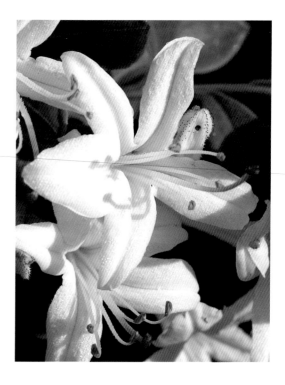

Swamp Azalea

Pine barrens Stream, Bass River State Forest

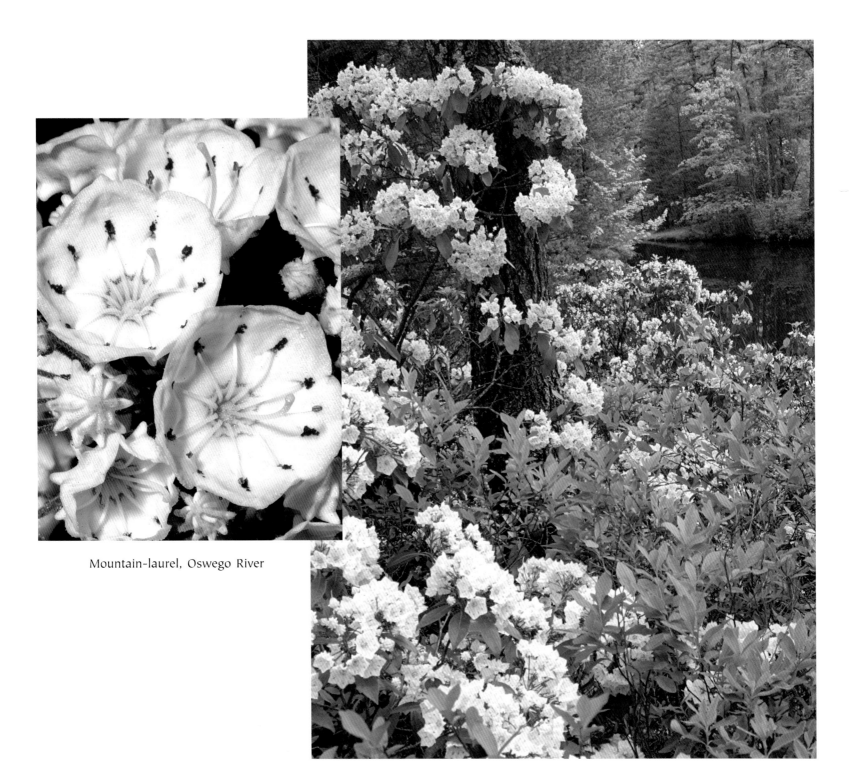

Mountain-laurel, Oswego River

23

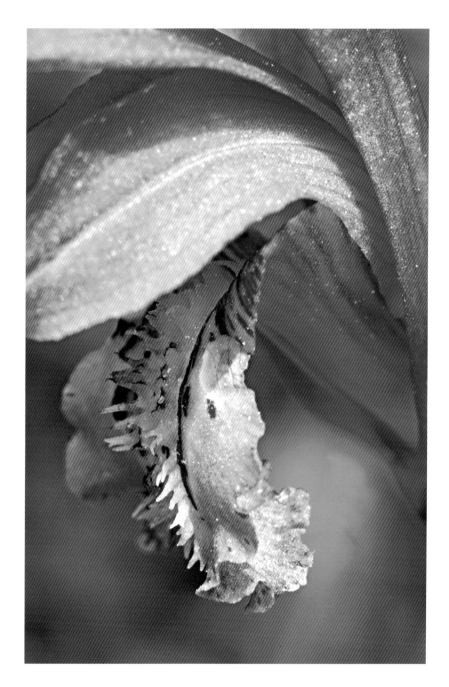

Dragon's Mouth

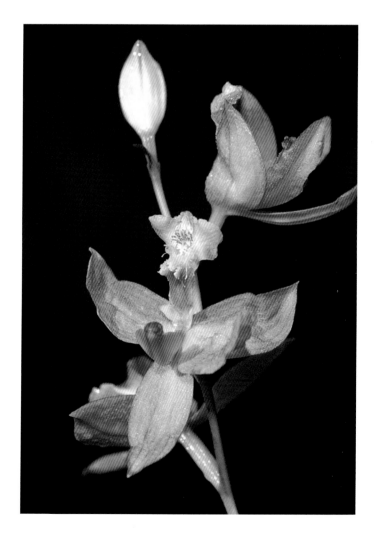

Grass-Pink

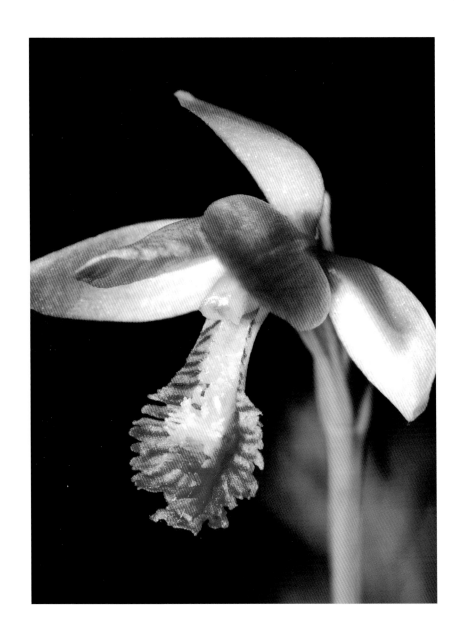

Rose Pogonia

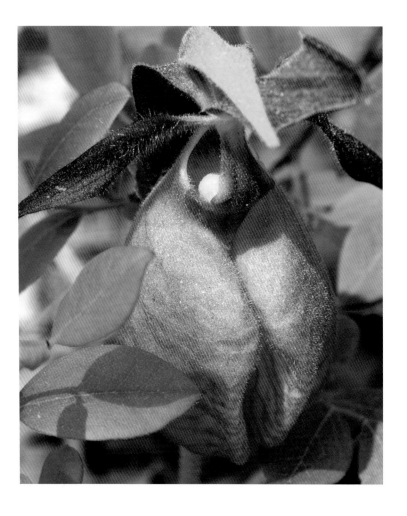

Pink Lady's-Slipper

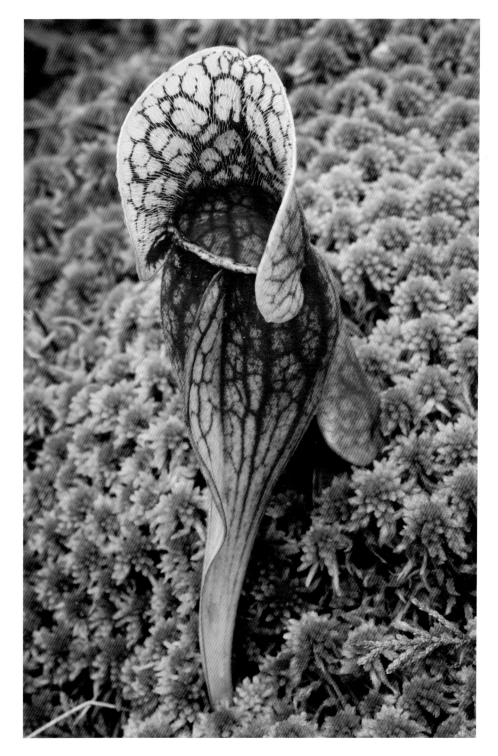

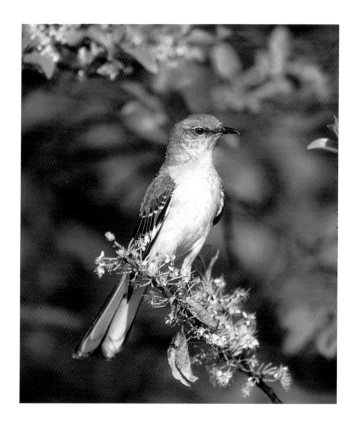

Mockingbird on Beach Plum

Pitcher-plant on Sphagnum Moss

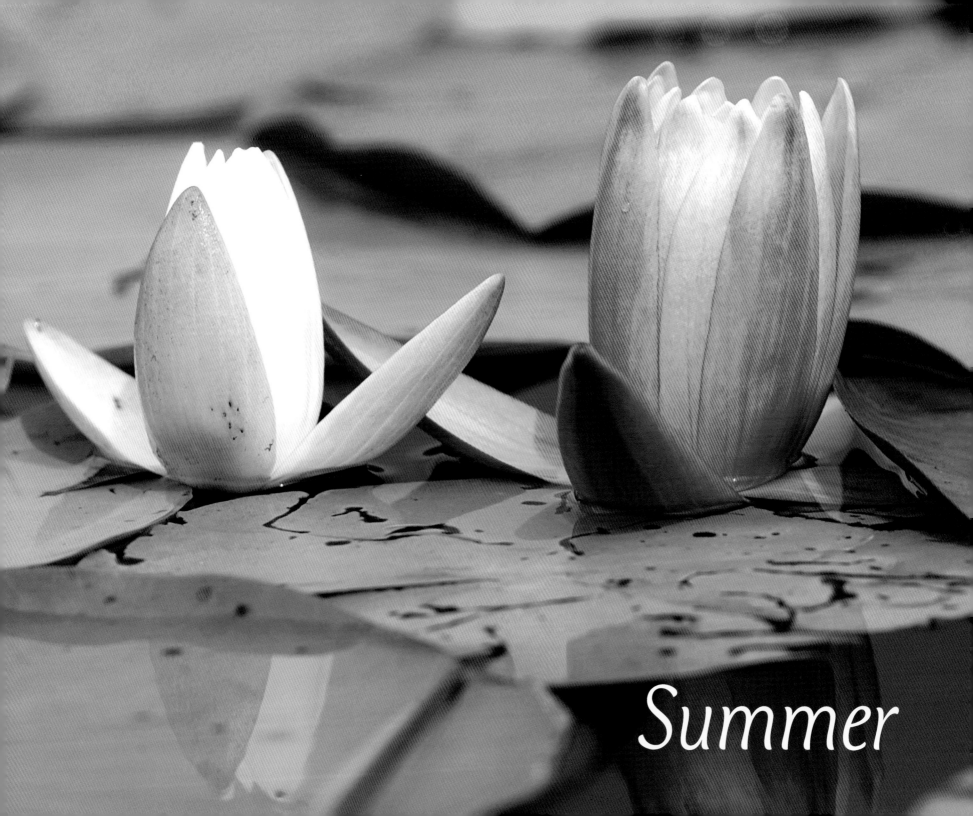

Summer

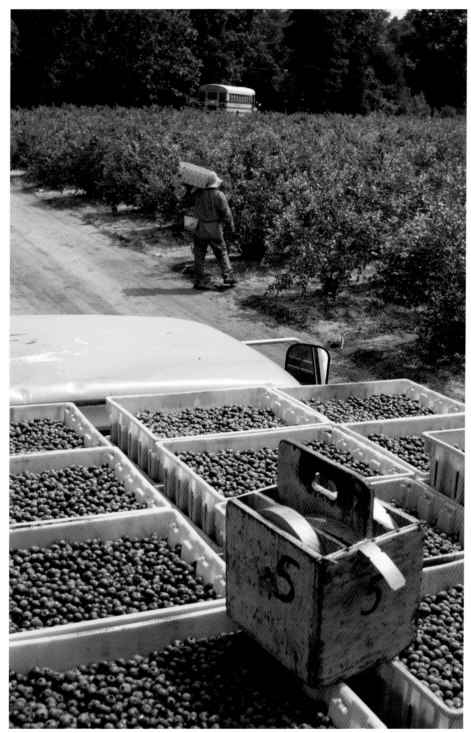

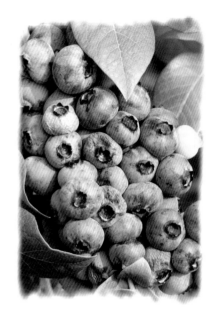

The Blueberry Harvest
Hammonton Area

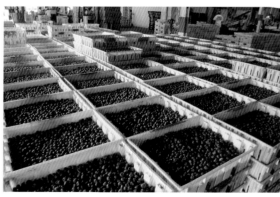

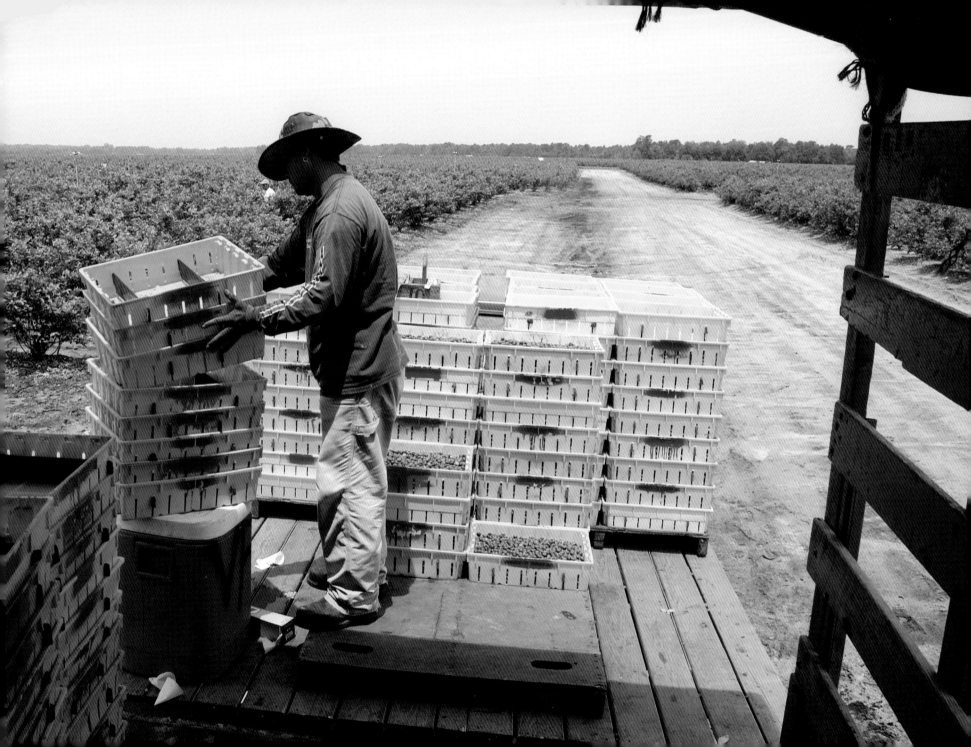

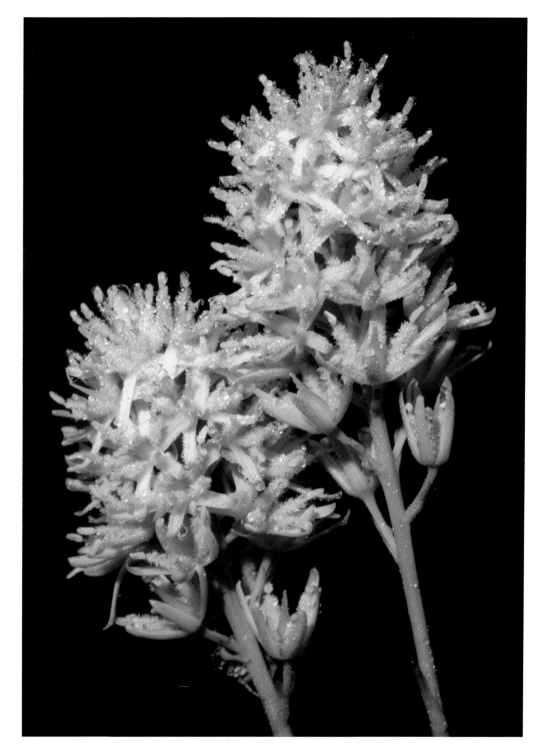

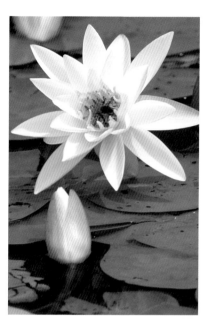

Water Lillies

Bog-asphodel, threatened species

Wood Duck

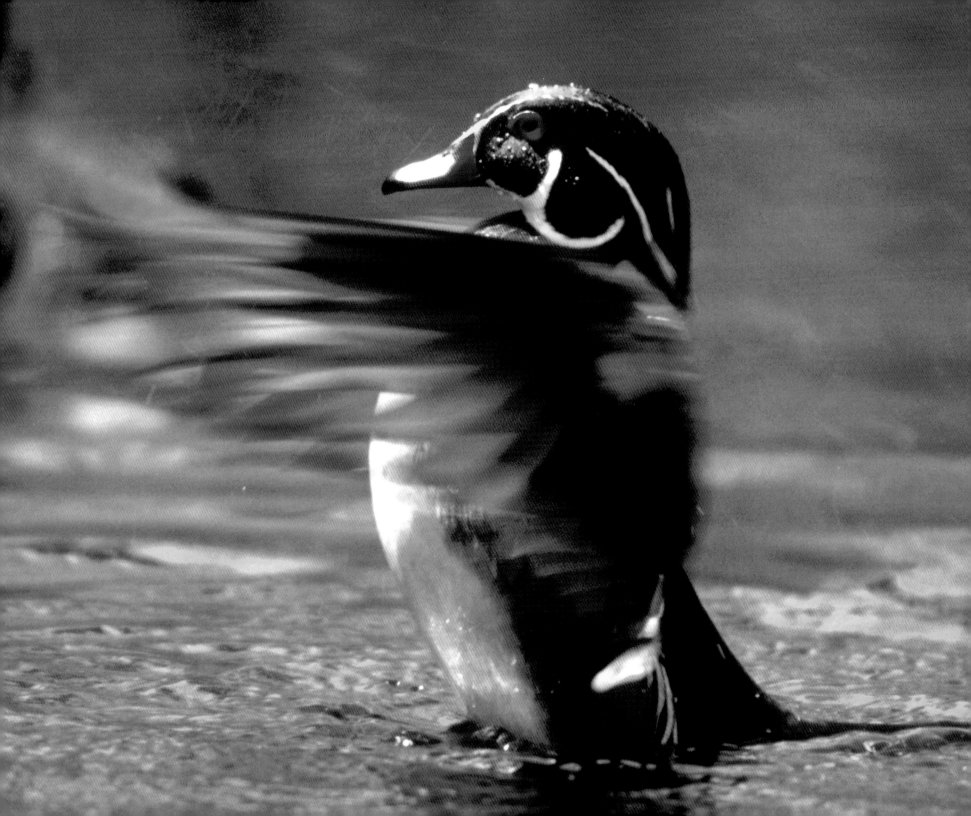

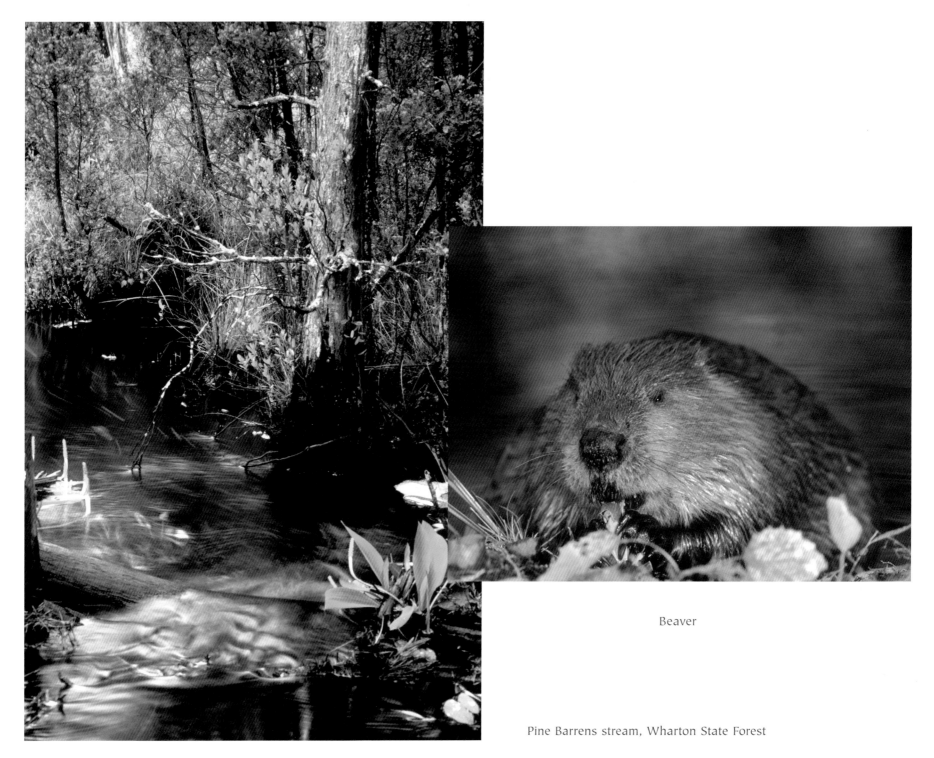

Beaver

Pine Barrens stream, Wharton State Forest

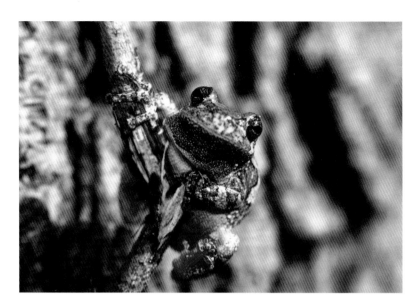

Grey Tree Frog

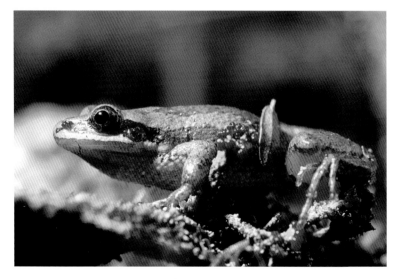

Chorus Frog

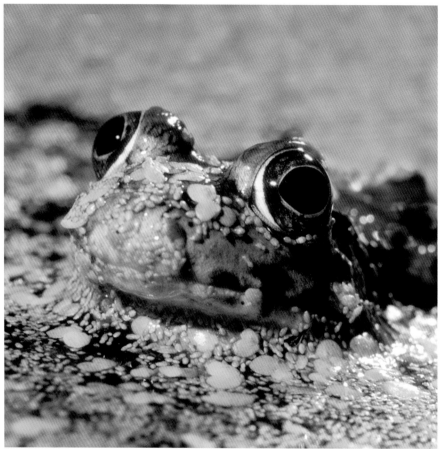

Bullfrog

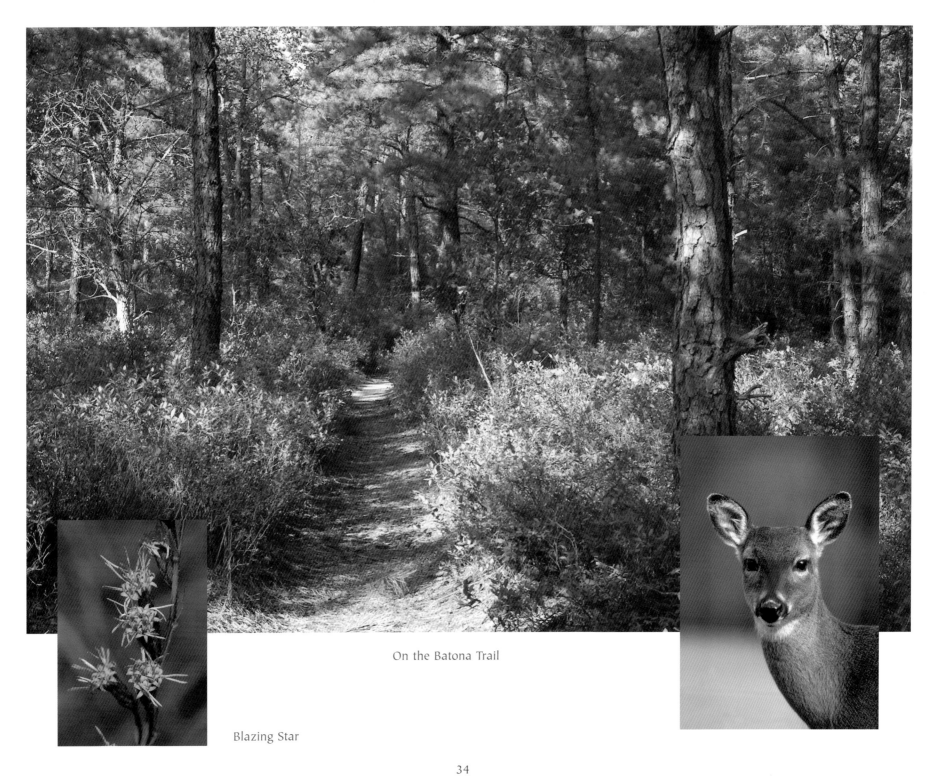

On the Batona Trail

Blazing Star

34

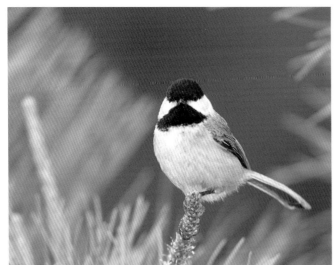

Chickadee

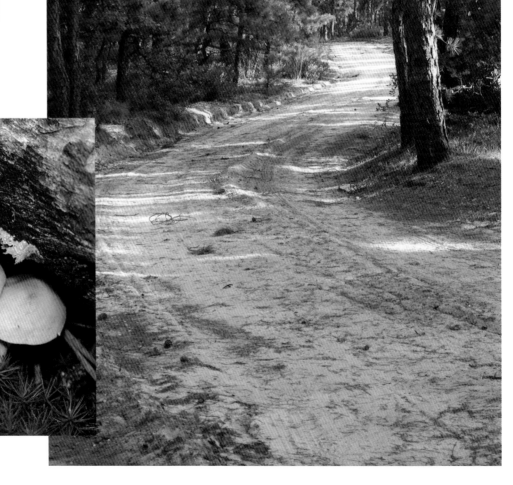

35

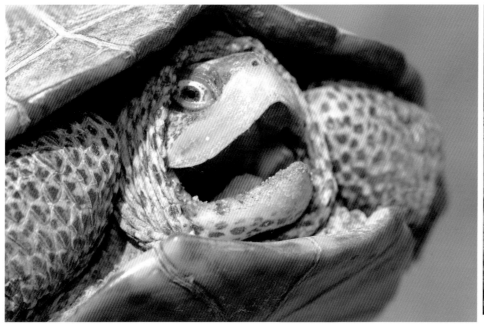

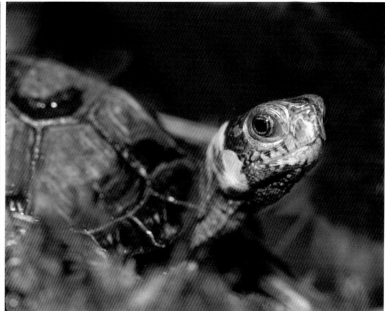

Diamondback Turtle

Bog Turtle, endangered species

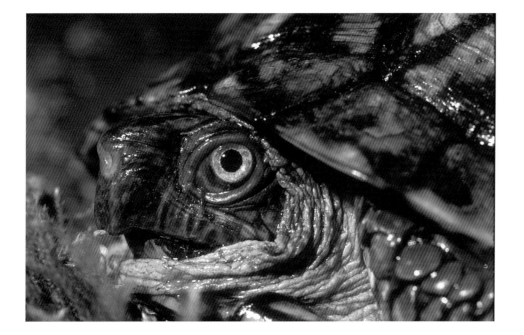

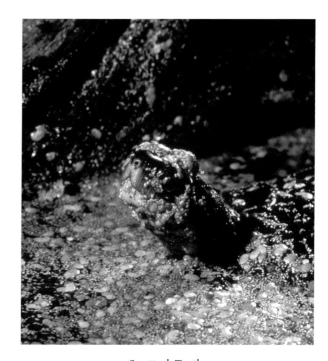

Eastern Box Turtle

Spotted Turtle

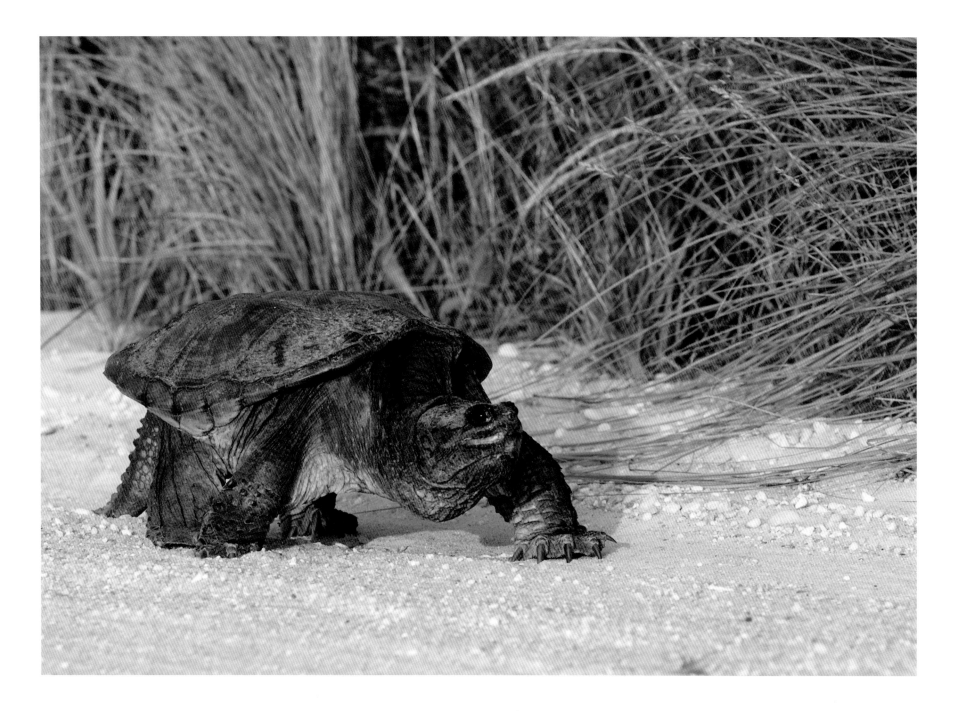

Snapping Turtle

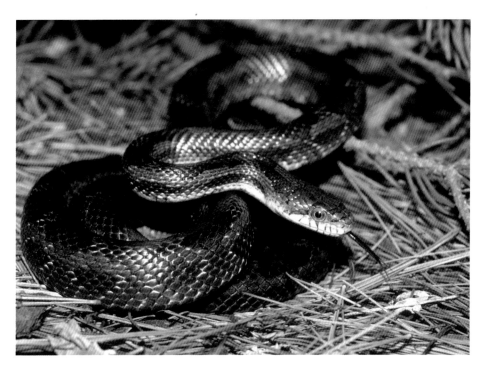

Black Rat Snake

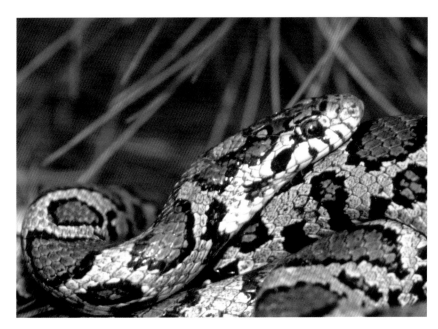

Milk Snake

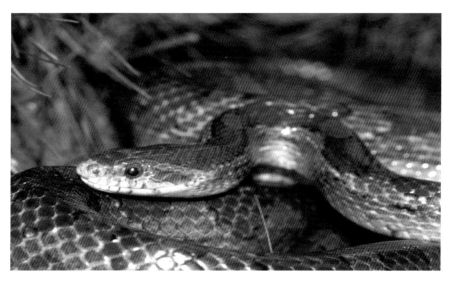

Corn Snake, endangered species

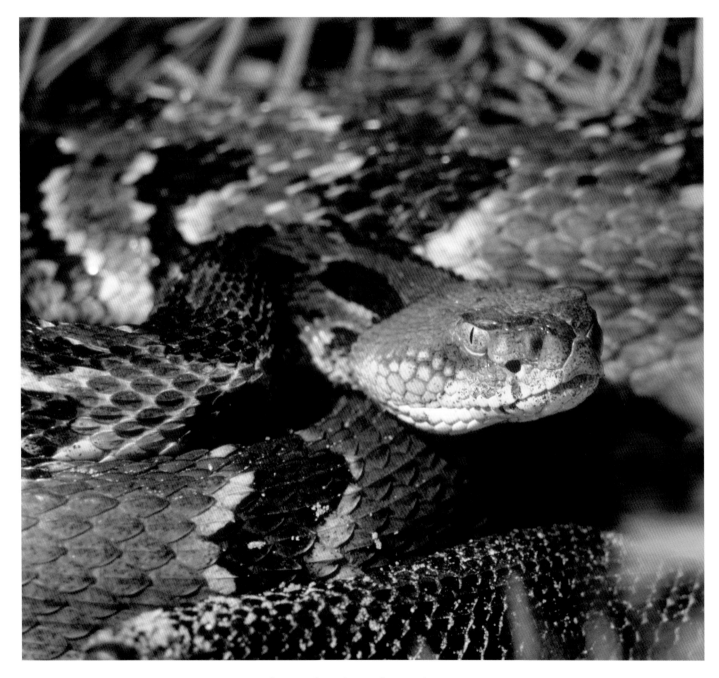

Timber Rattlesnake, endangered species

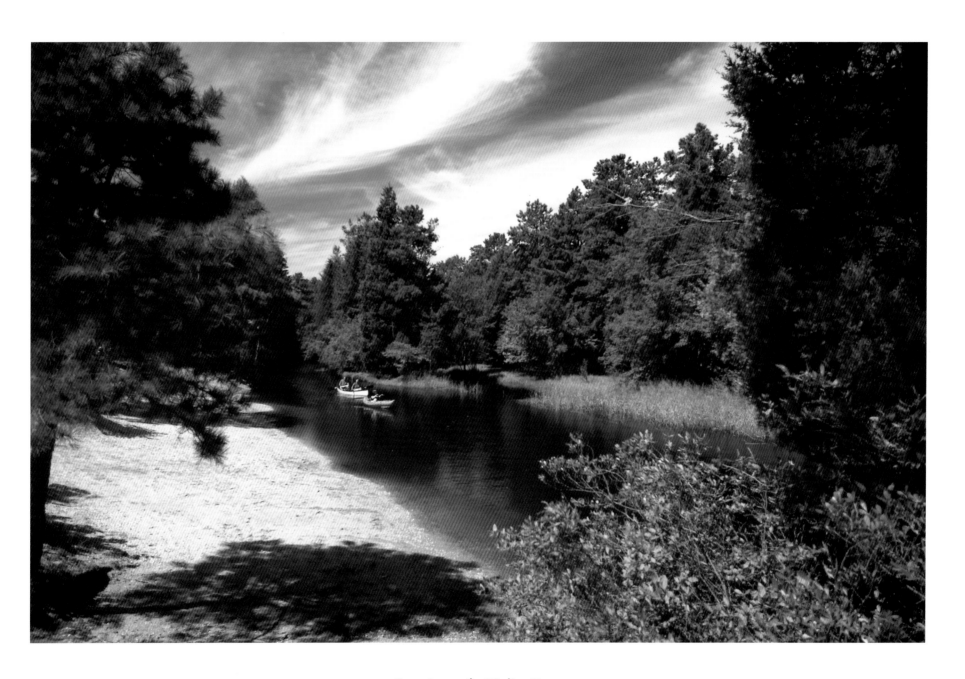

Canoeing on the Wading River

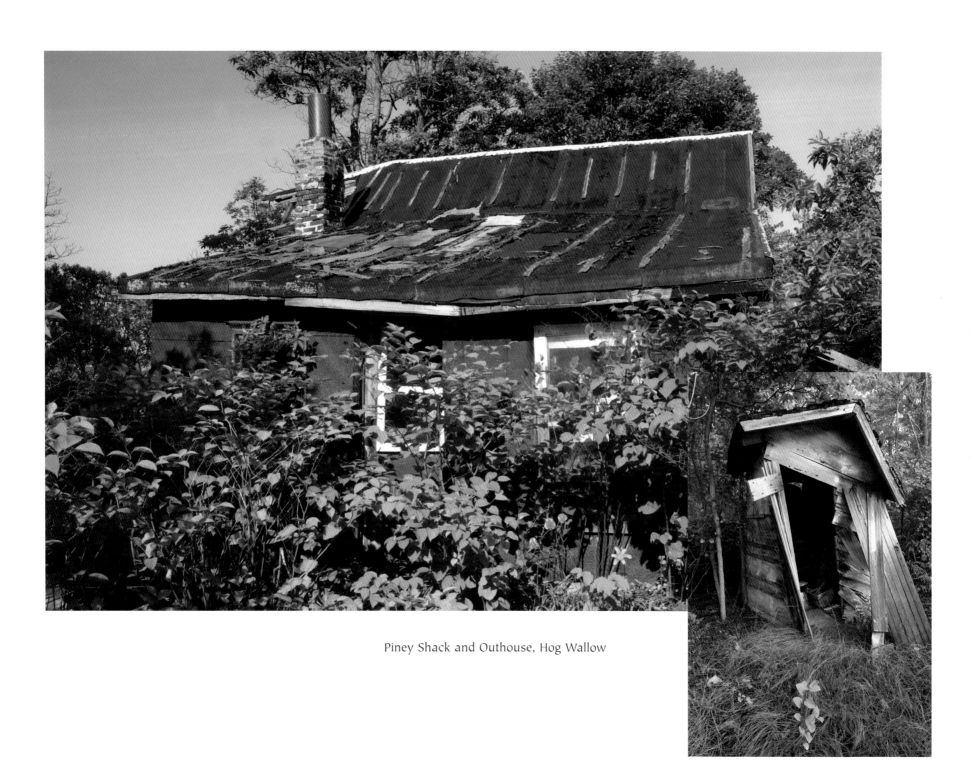

Piney Shack and Outhouse, Hog Wallow

Spatulate-Leaved Sundew

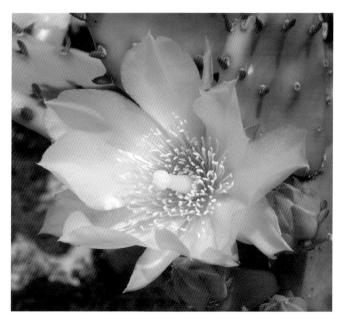

Prickly Pear

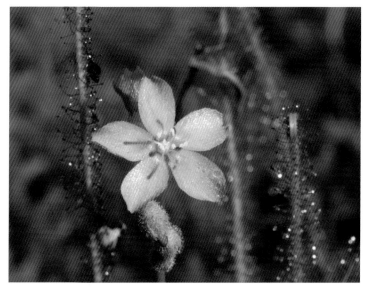

Thread-Leaved Sundew

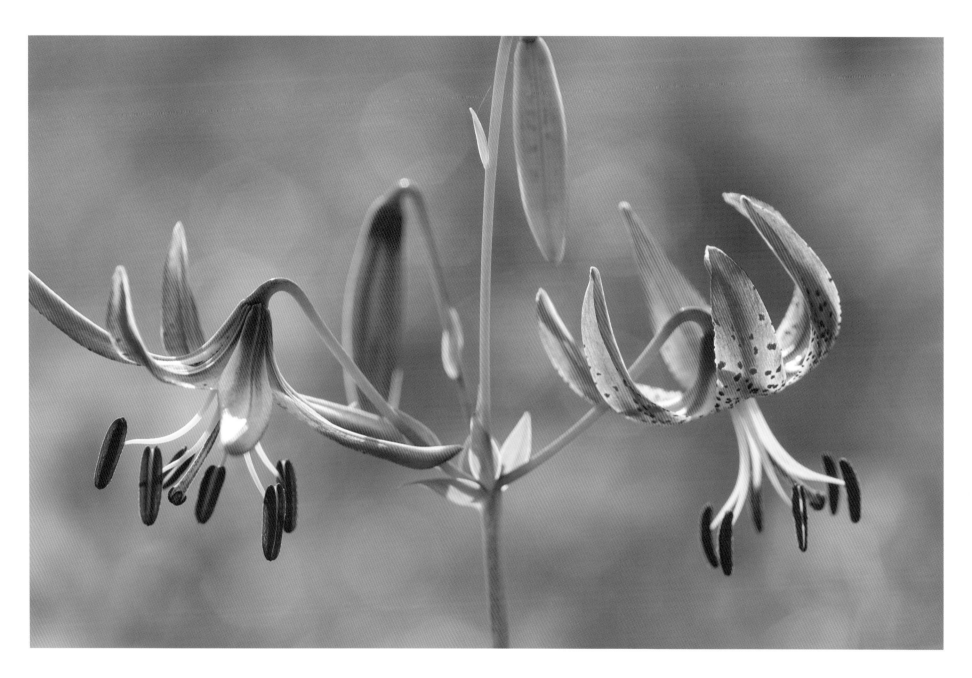

Turk's-Cap Lily

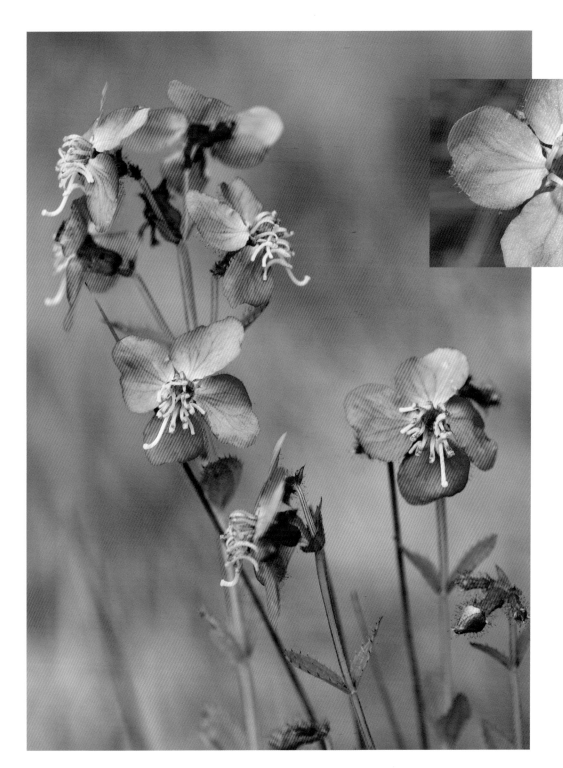

Meadow Beauty

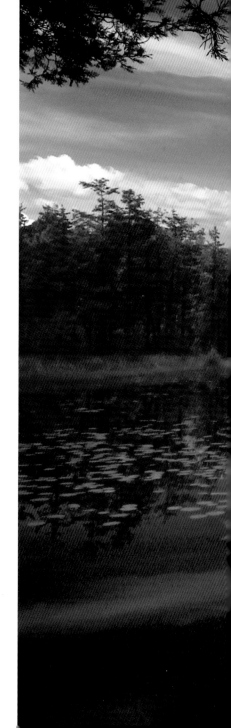

Oswego Lake

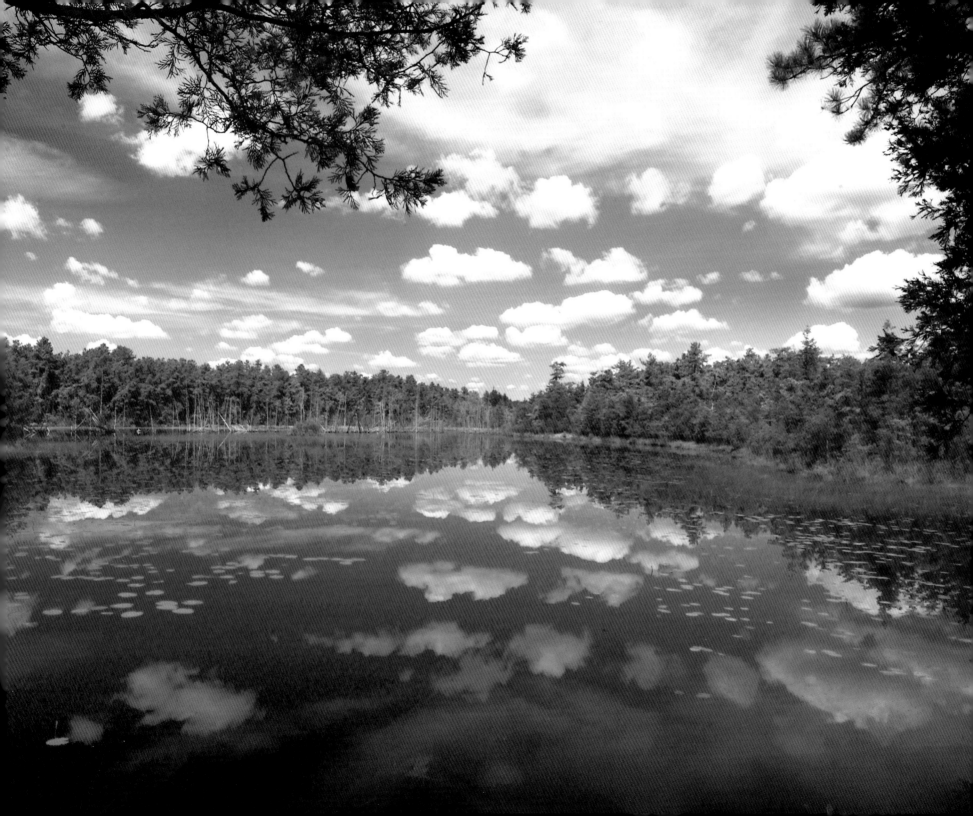

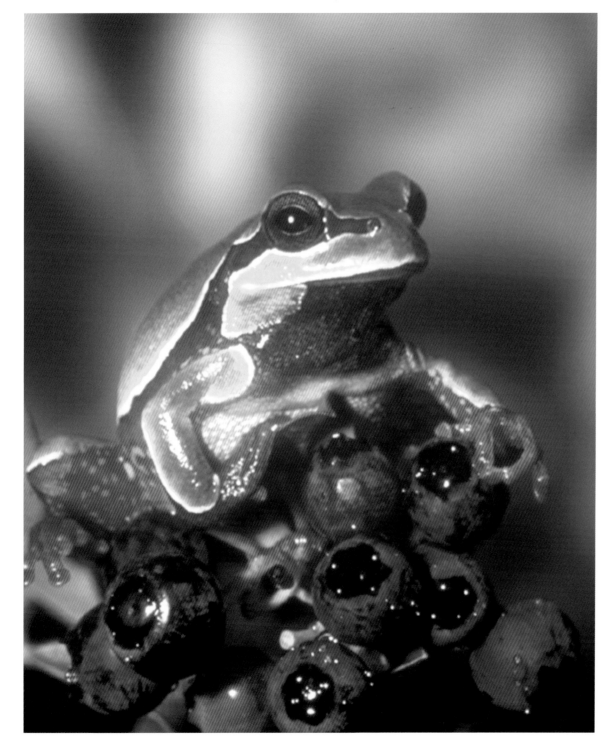

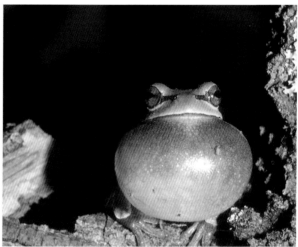

Pine Barrens Tree Frog, endangered species

46

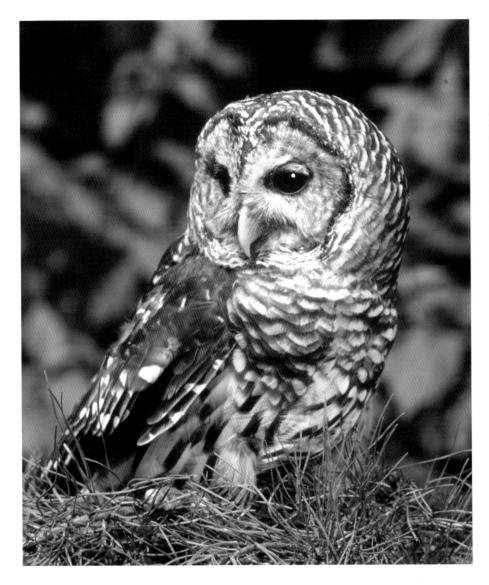

Barred Owl, threatened species

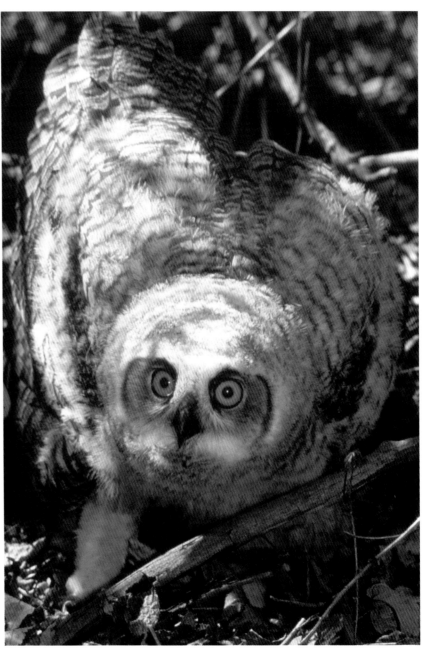

Young Great Horned Owl

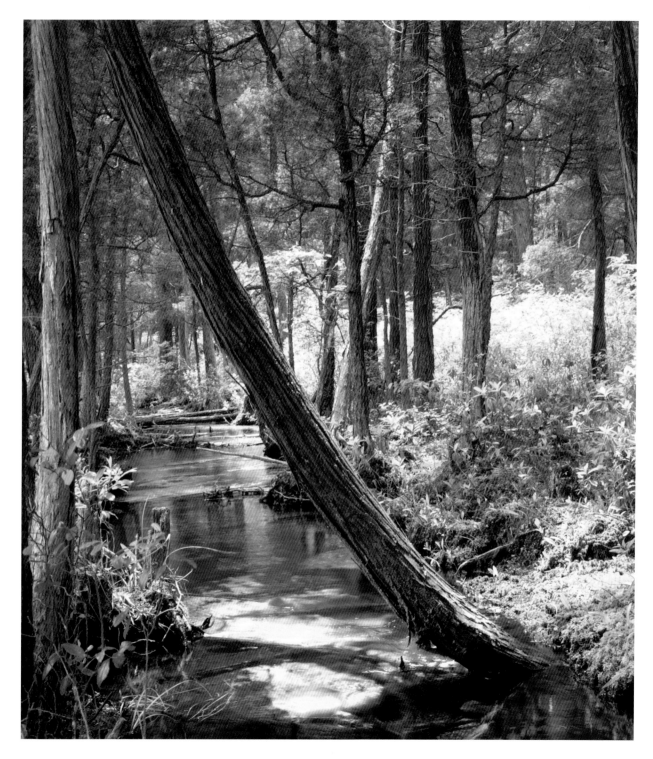

Cold Brook, Forked River Mountains area

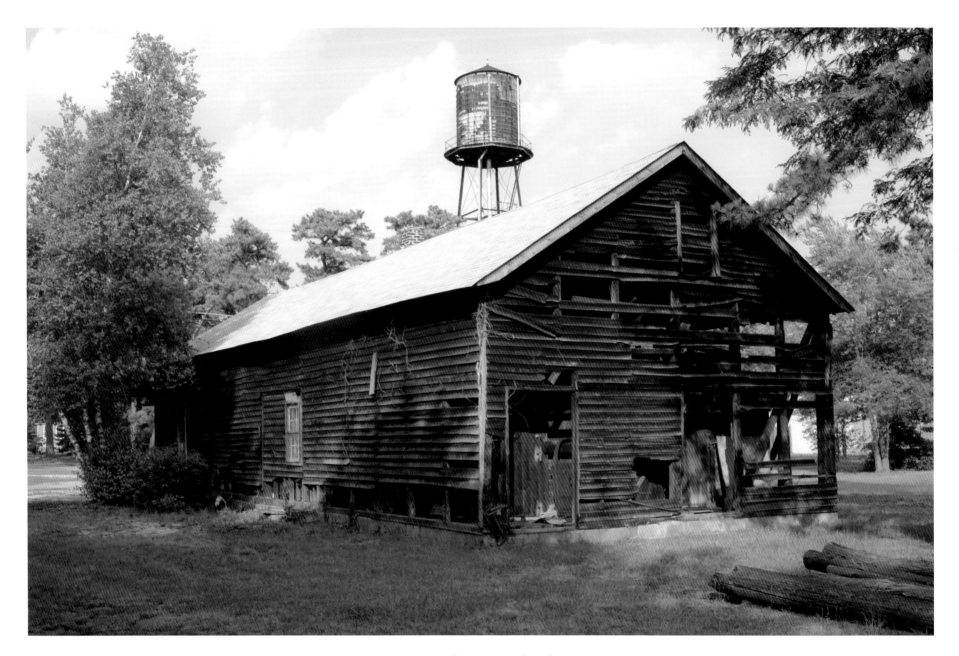

Barn and Tower at Whitesbog

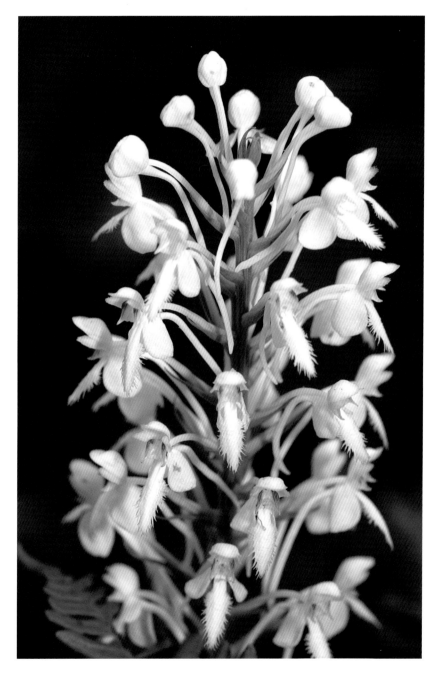

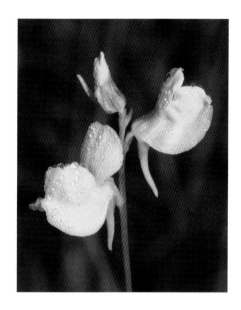

Horned Bladderwort

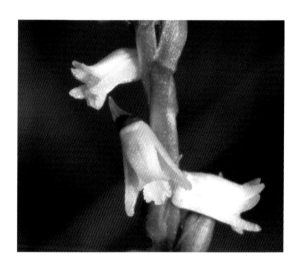

Little Ladies' Tresses, threatened
species

White Fringed Orchid

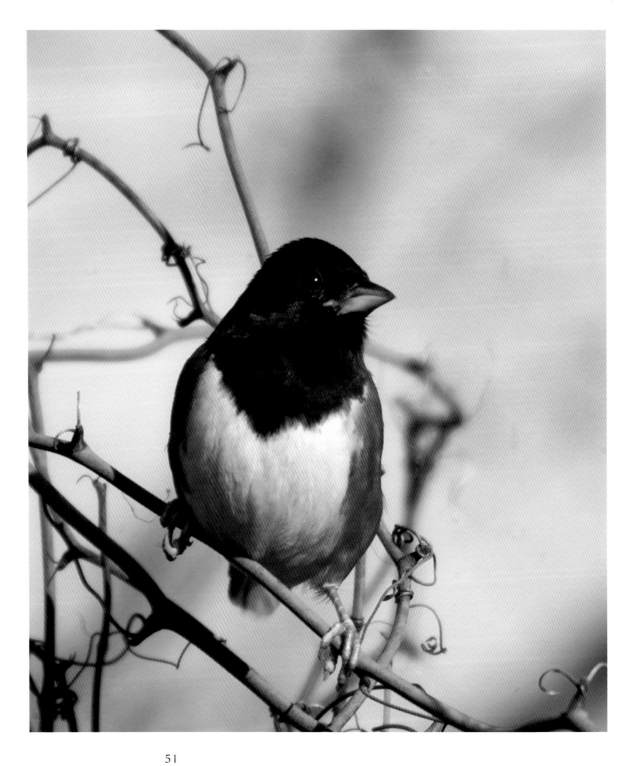

Rufus-sided Towhee

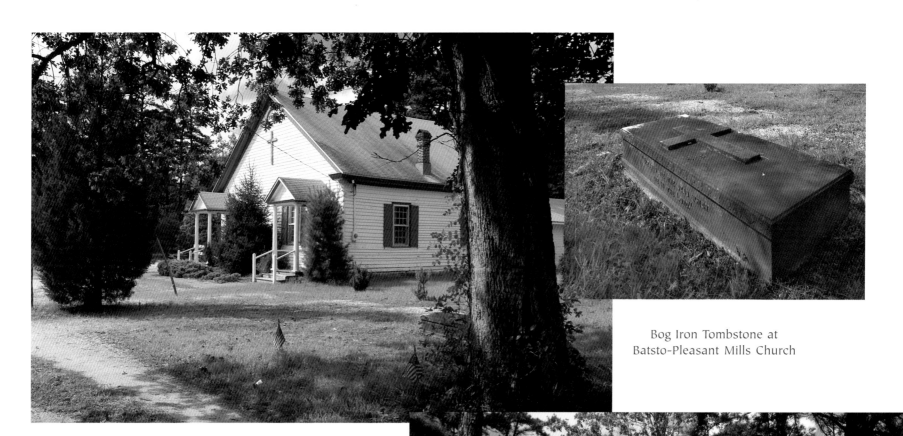

Bog Iron Tombstone at
Batsto-Pleasant Mills Church

Batsto-Pleasant Mills Church (1808)

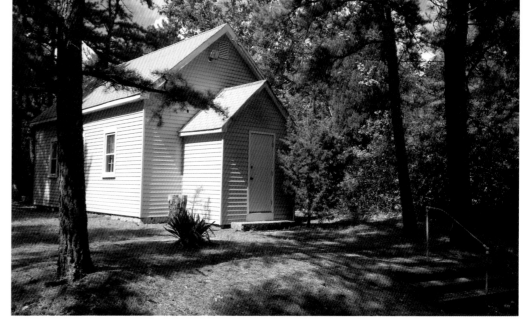

Jenkins Chapel in the Pines (1889)

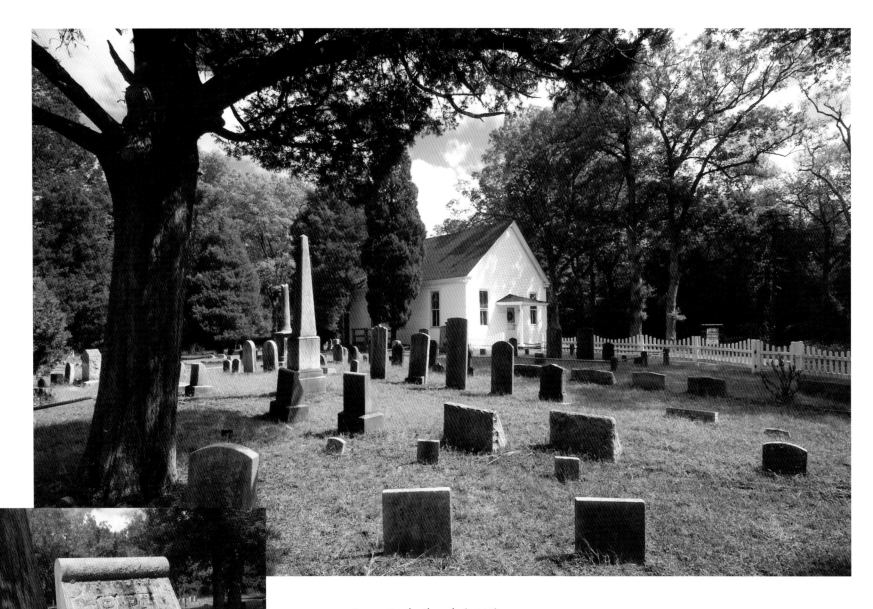

Green Bank Church (1748)

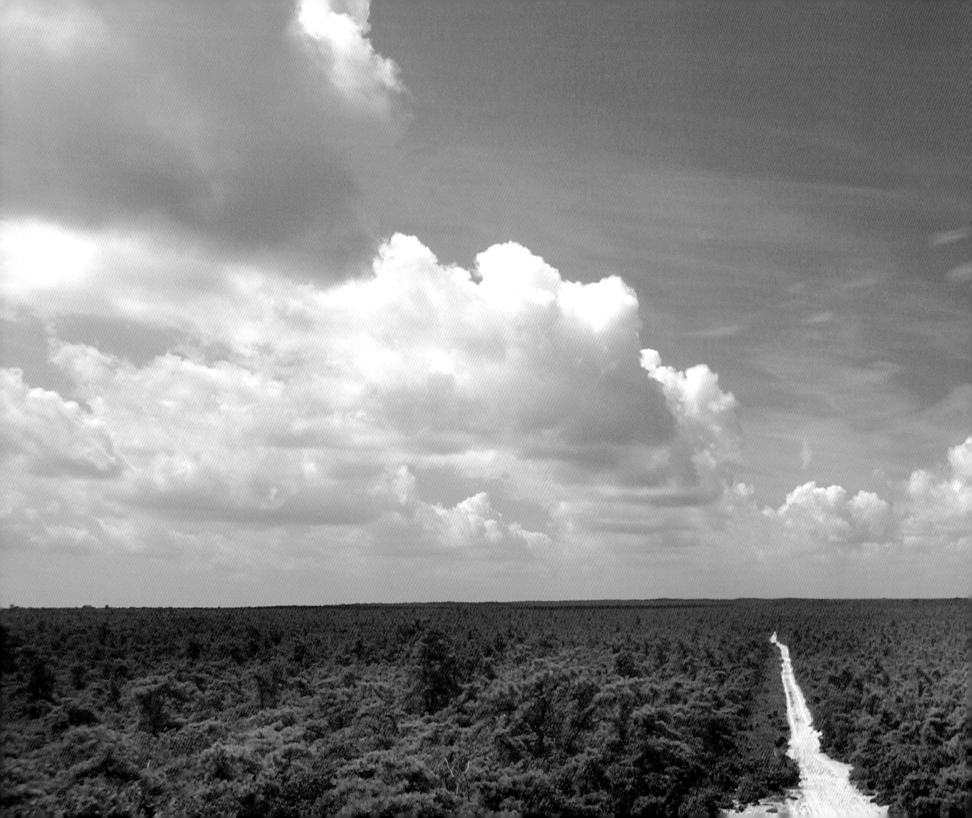

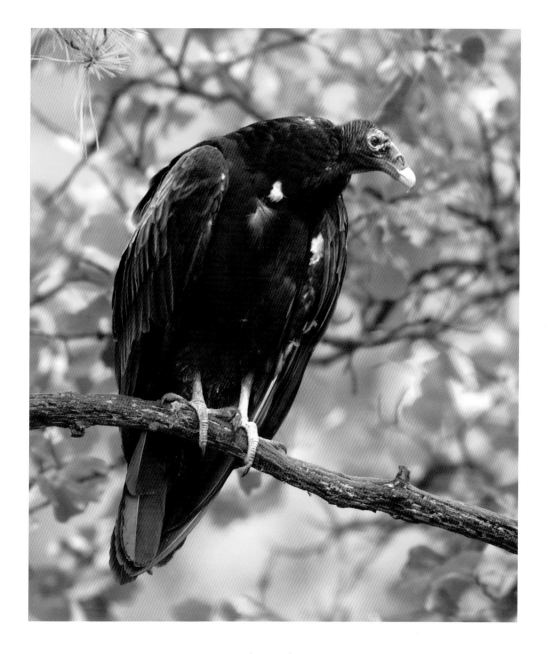

Turkey Vulture

Previous pages 54-55, The Pygmy Pines, West Plains

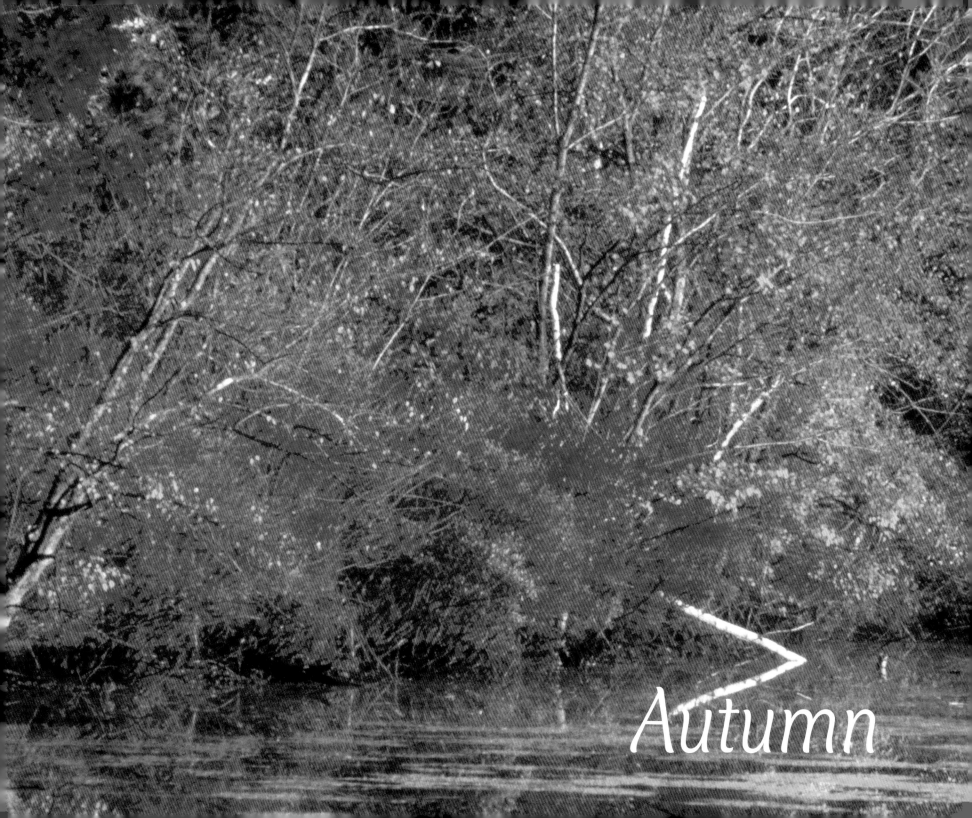

Autumn

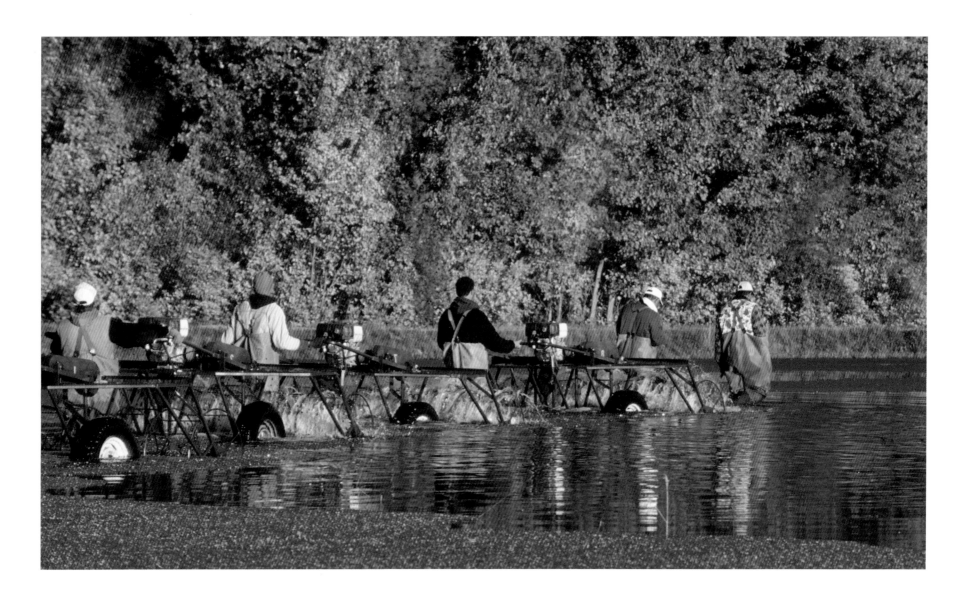

The Cranberry Harvest
Chatsworth

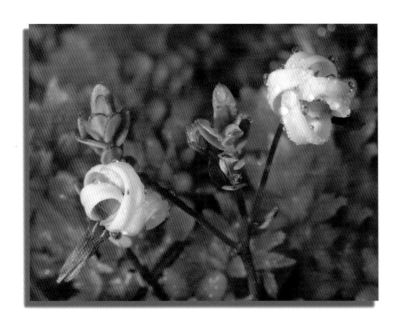

The American Cranberry

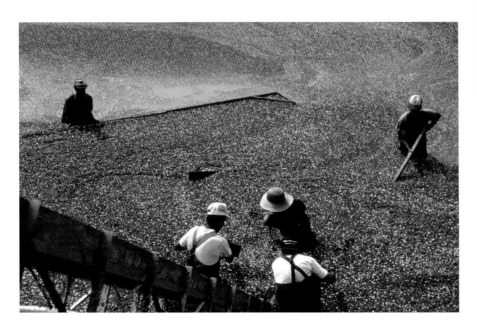

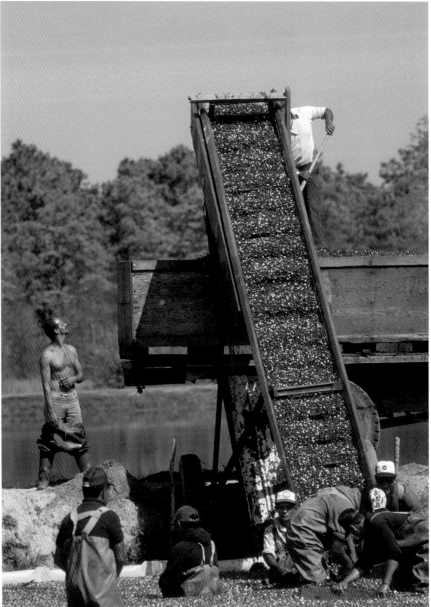

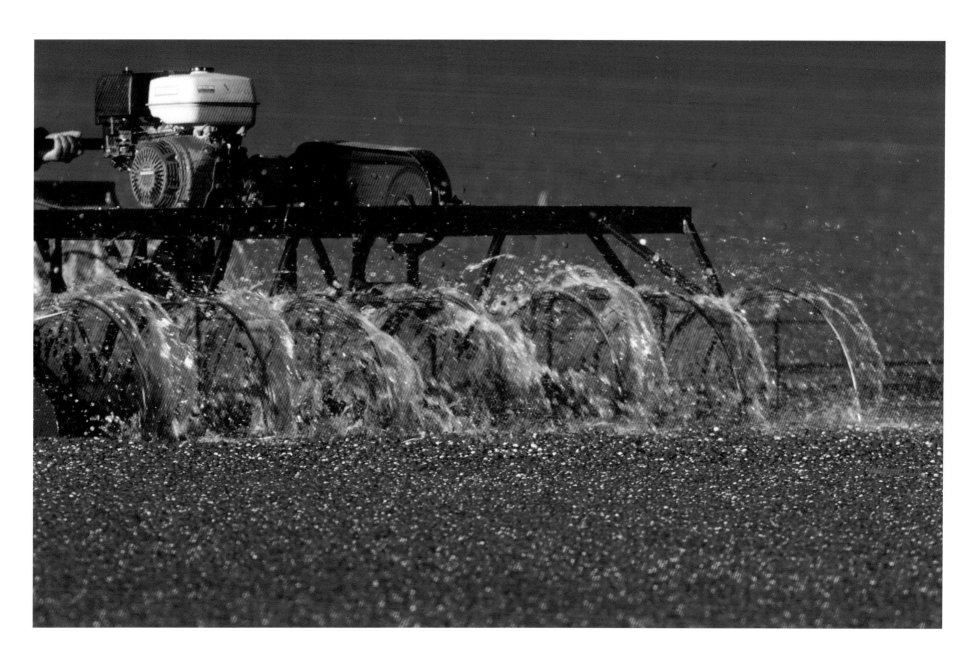

The foreman marks the path (right)

for the beating machines (left).

Cranberries stretch as far as the eye can see

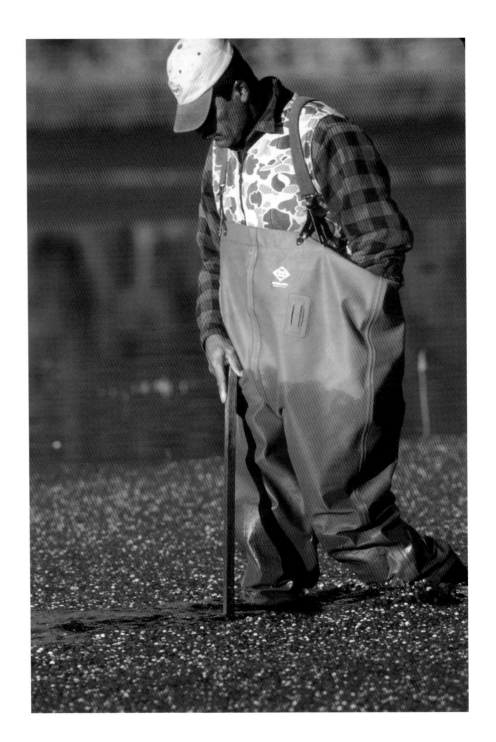

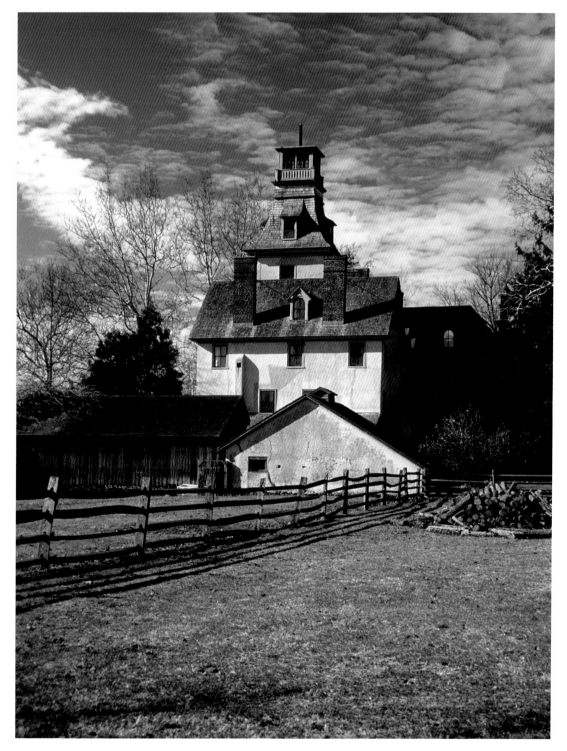

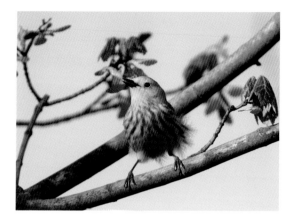

Yellow Warbler

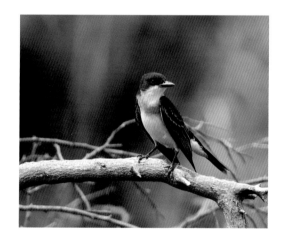

Eastern Kingbird

Batsto Mansion, Wharton State Forest
(Photo courtesy of Shail Jain, shot during one of my Pine Barrens Photo Tours).

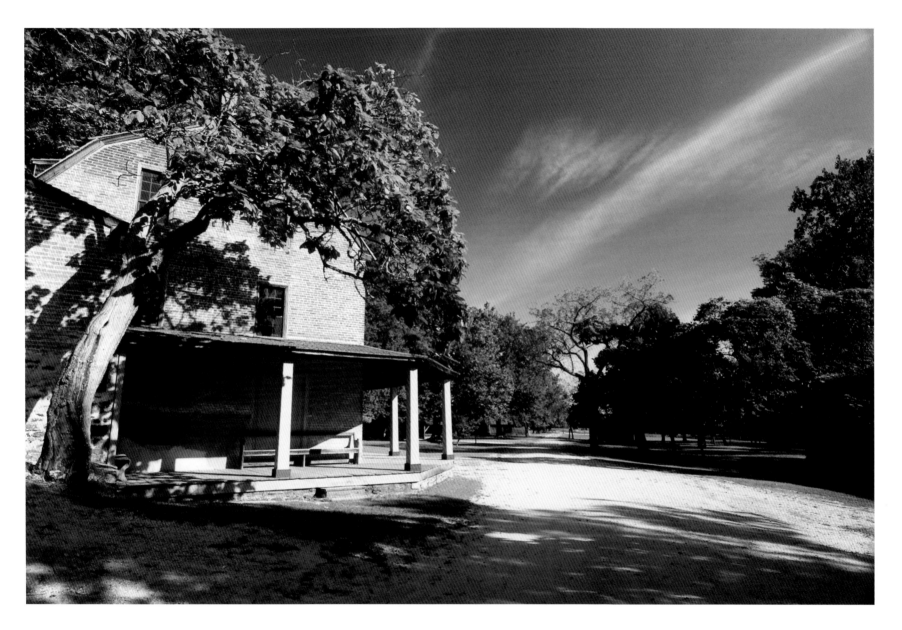

Batsto Company Store

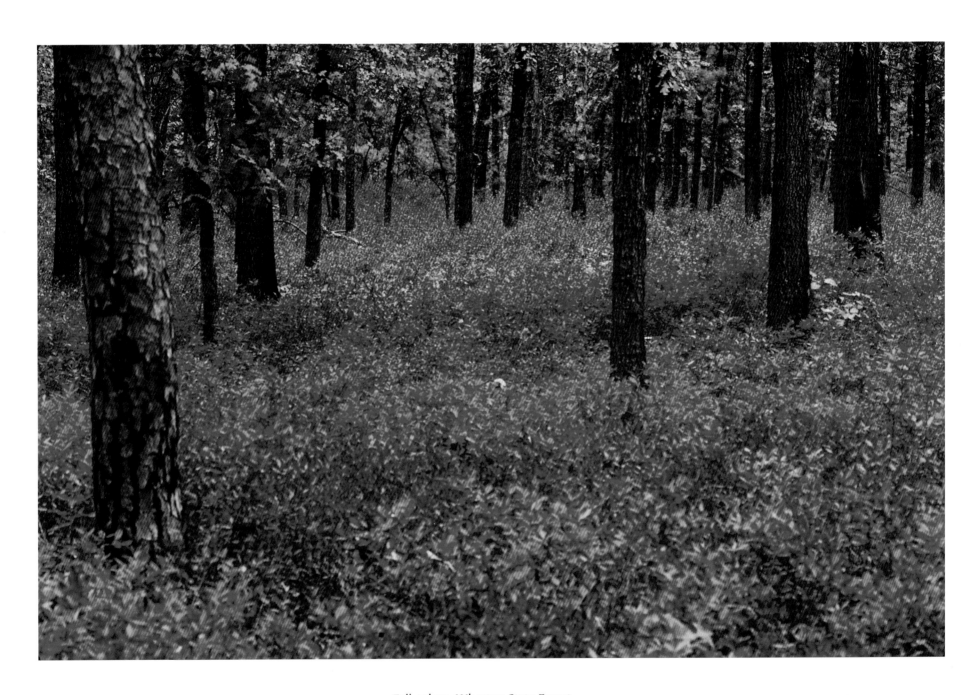

Fall colors, Wharton State Forest

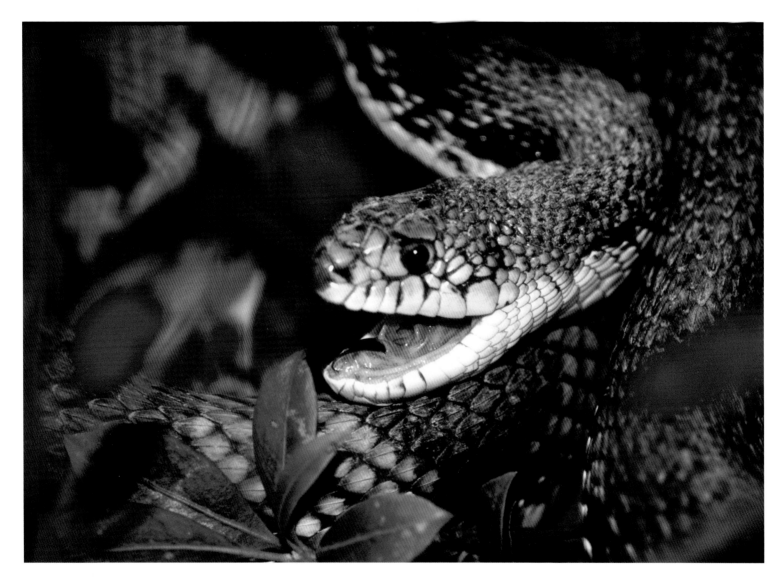

Northern Pine Snake, threatened species

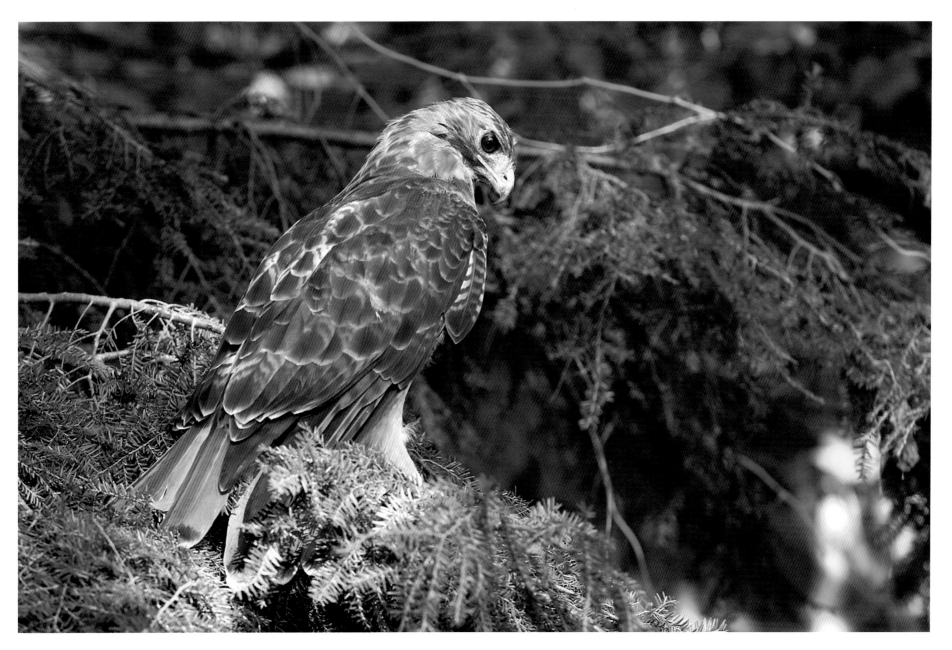

Red-tailed Hawk

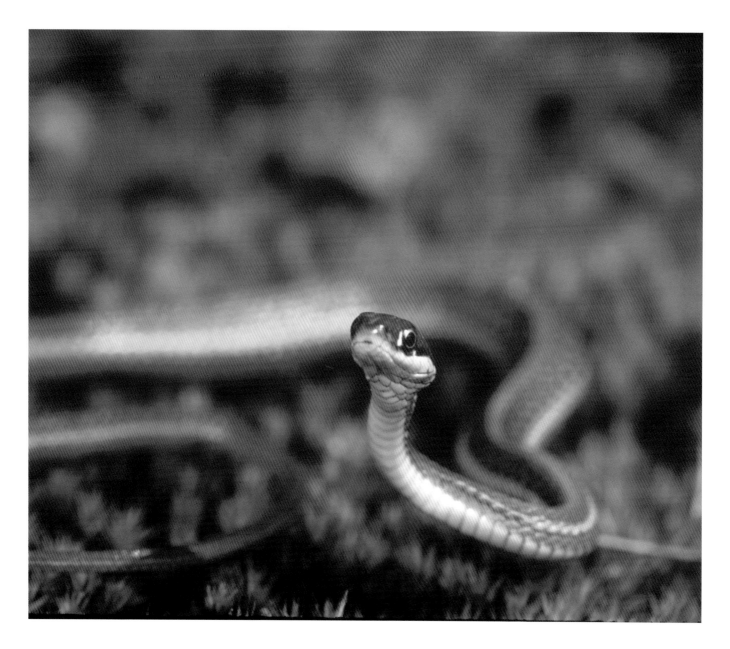

Eastern Ribbon Snake

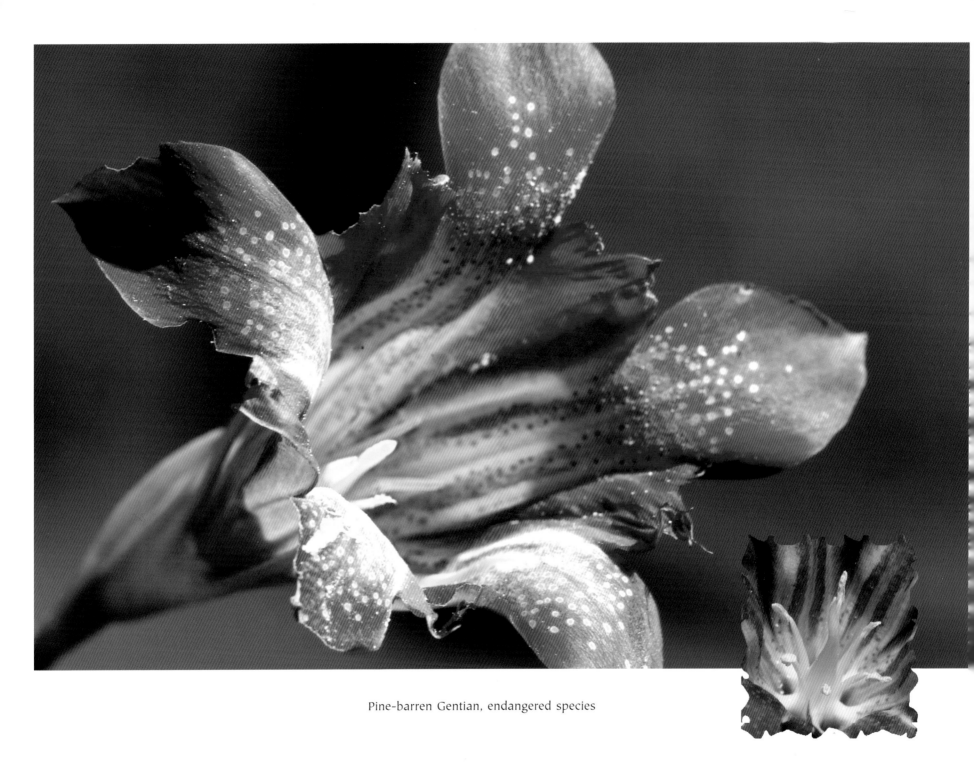

Pine-barren Gentian, endangered species

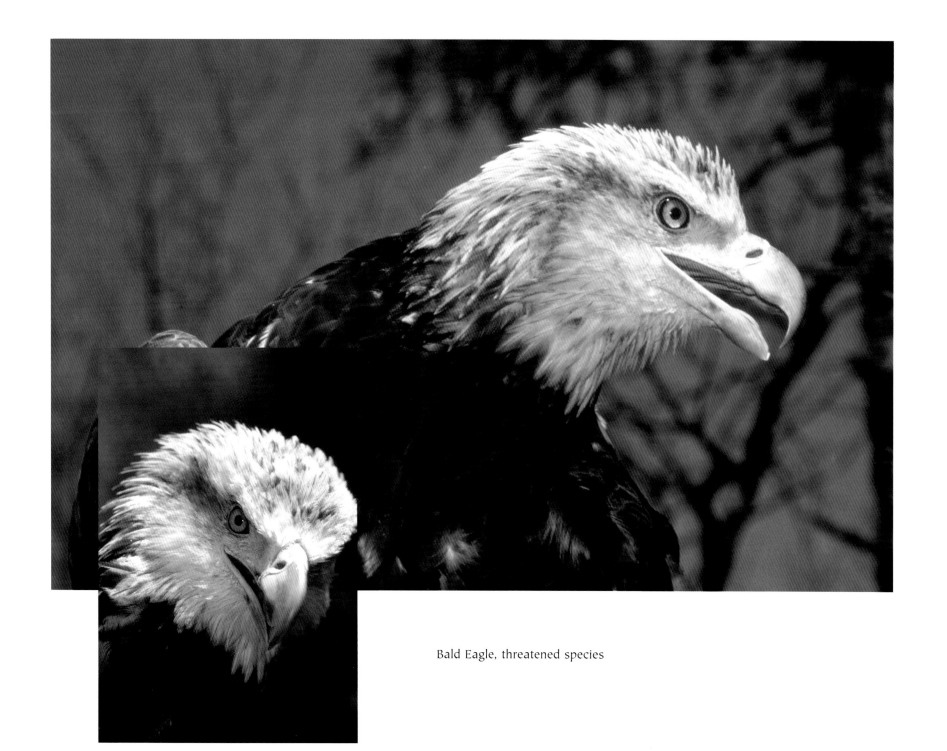

Bald Eagle, threatened species

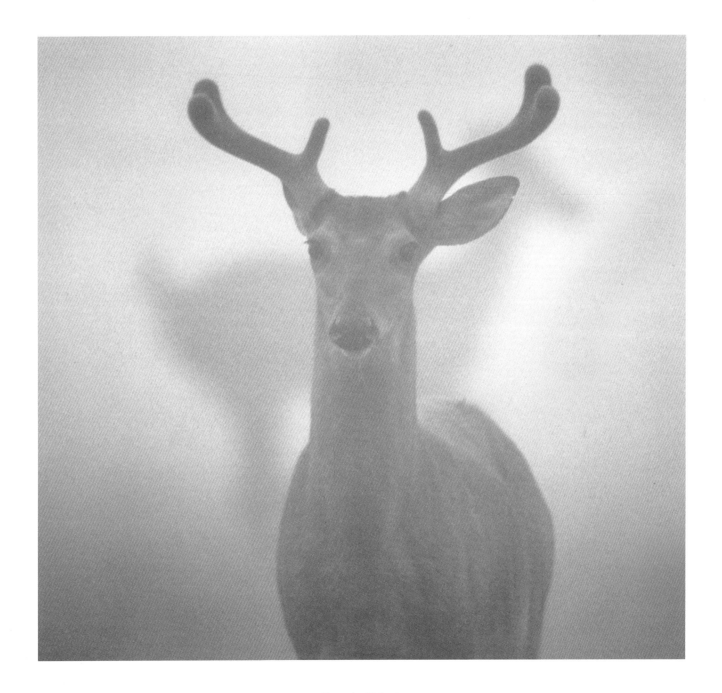

Deer in Velvet

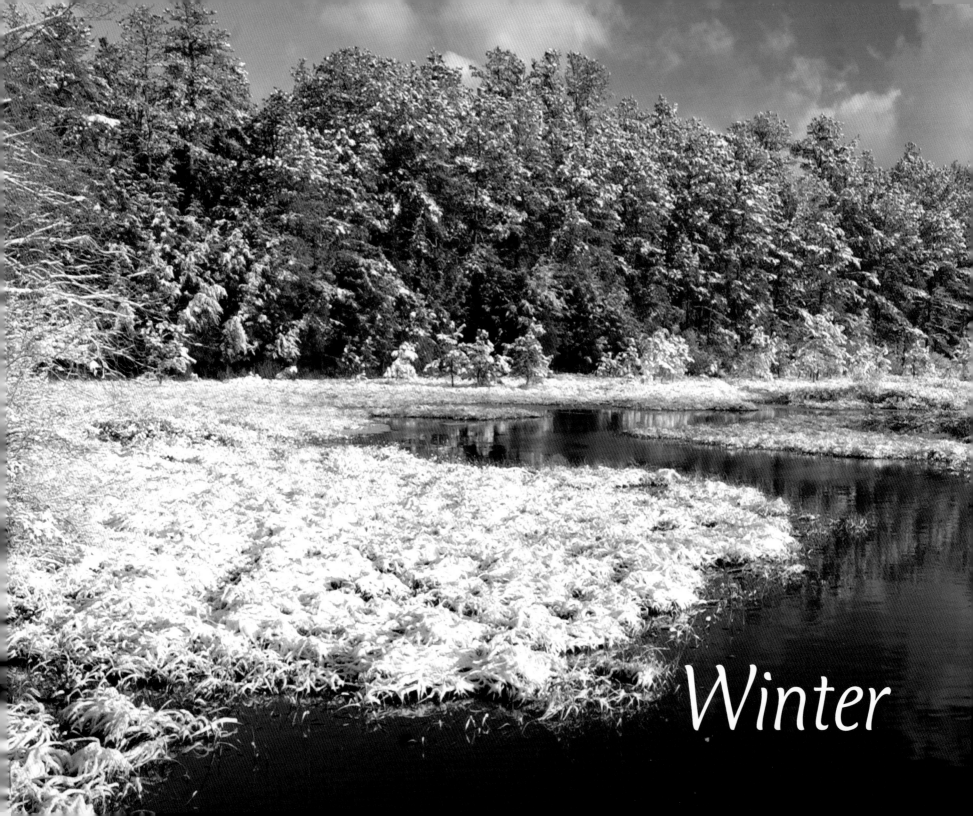

Winter

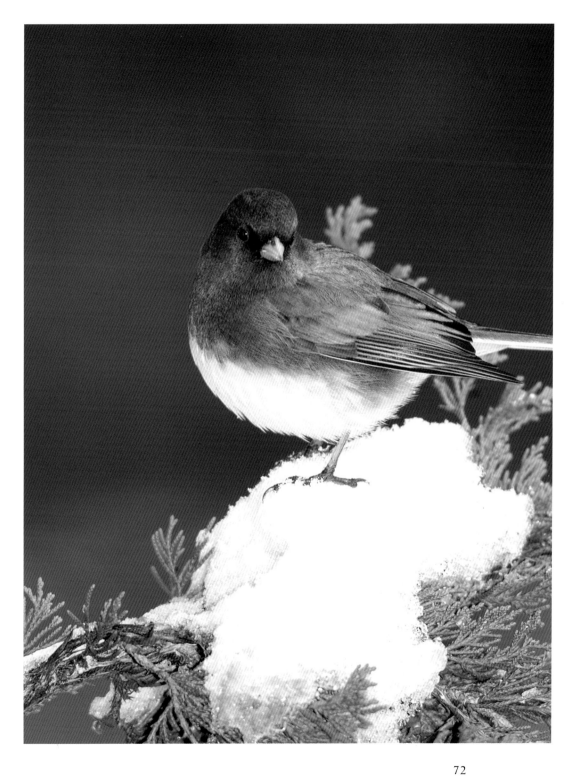

Dark-eyed Junco

Chickadee

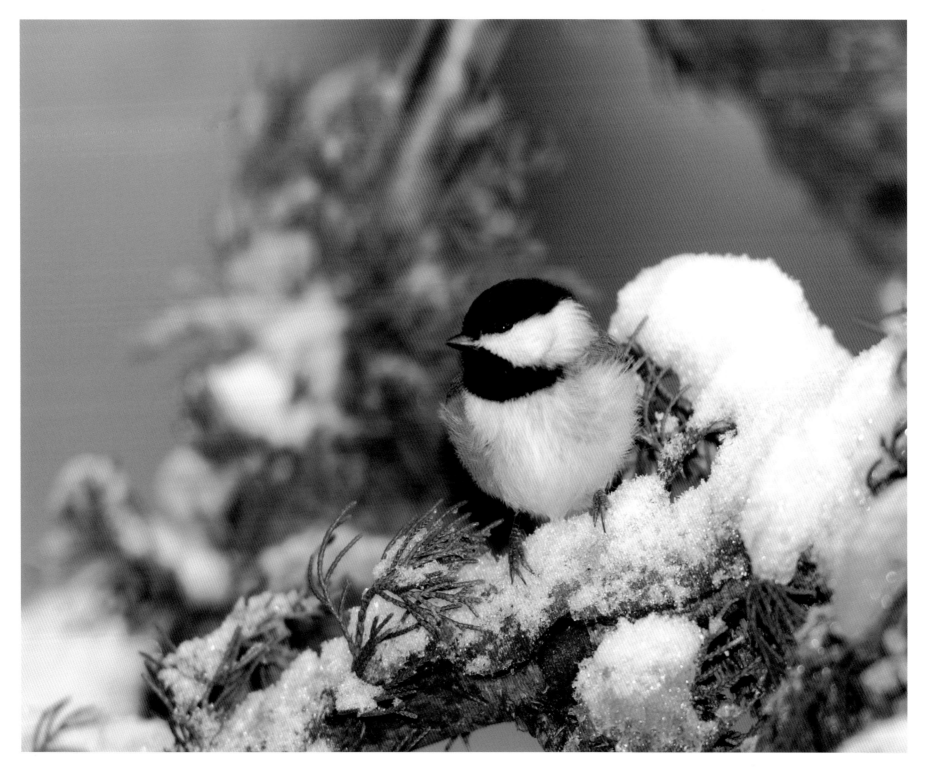

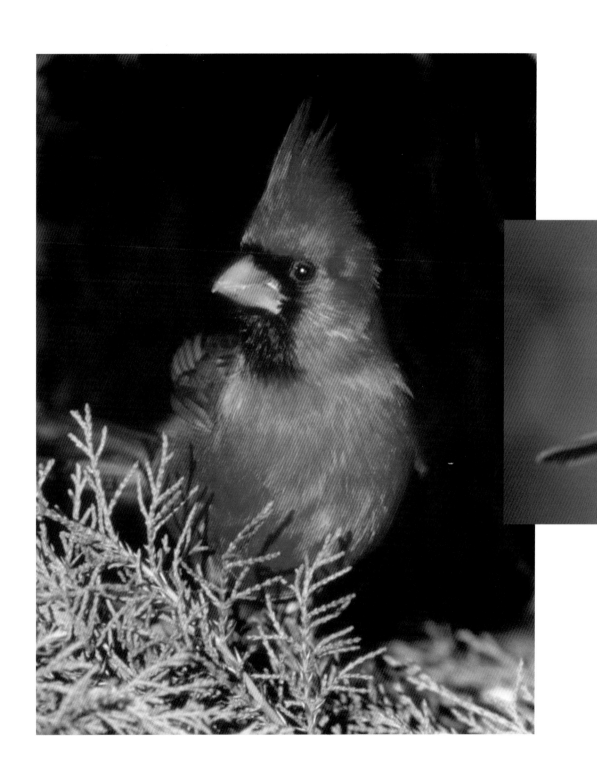

Male and Female American Cardinals

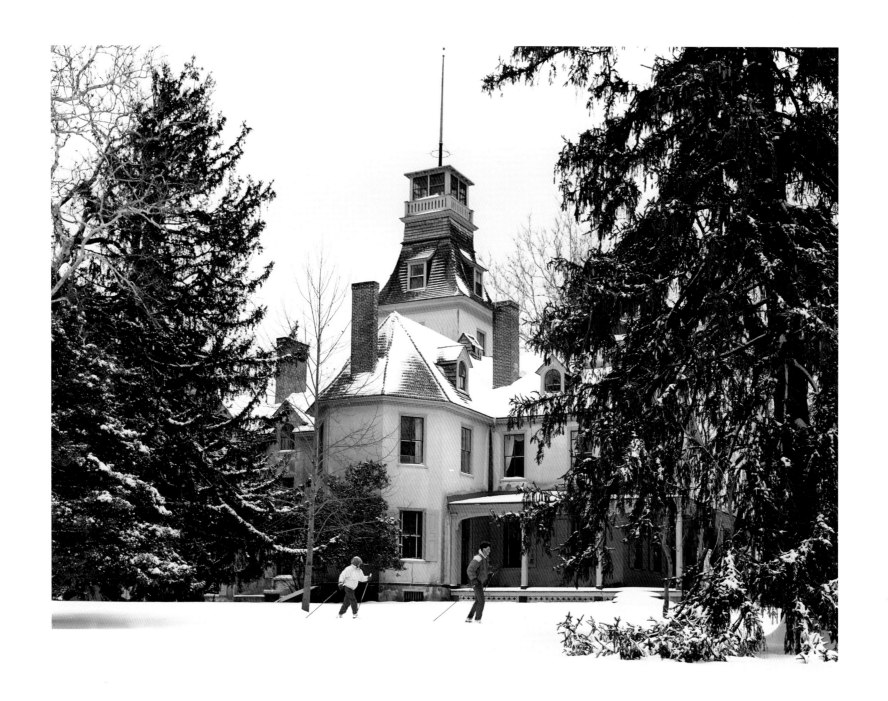

Batsto Mansion in Snow

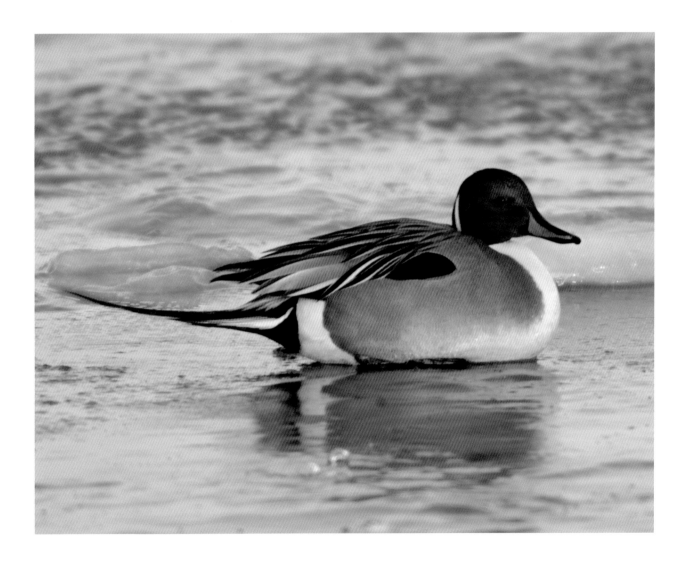

Pintail Drake

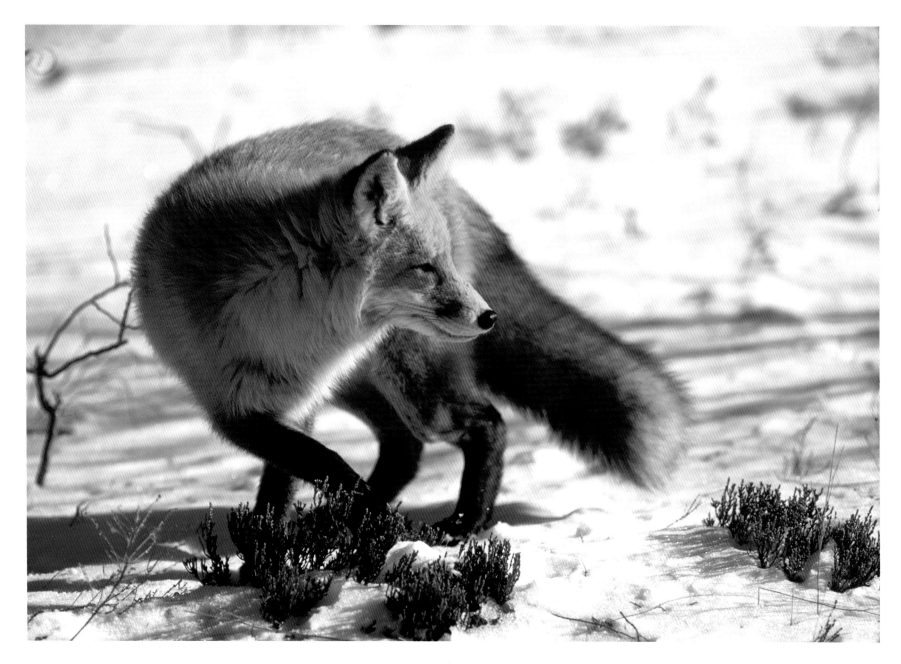

Red Fox

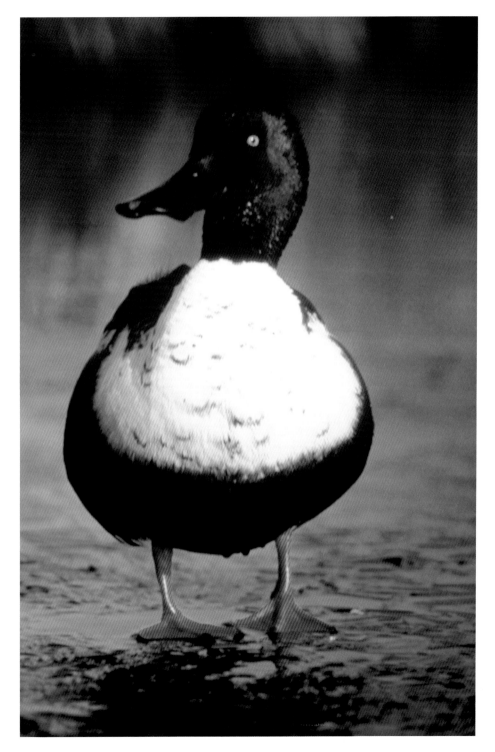

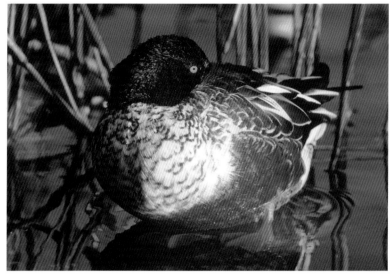

Northern Shovelers on ice

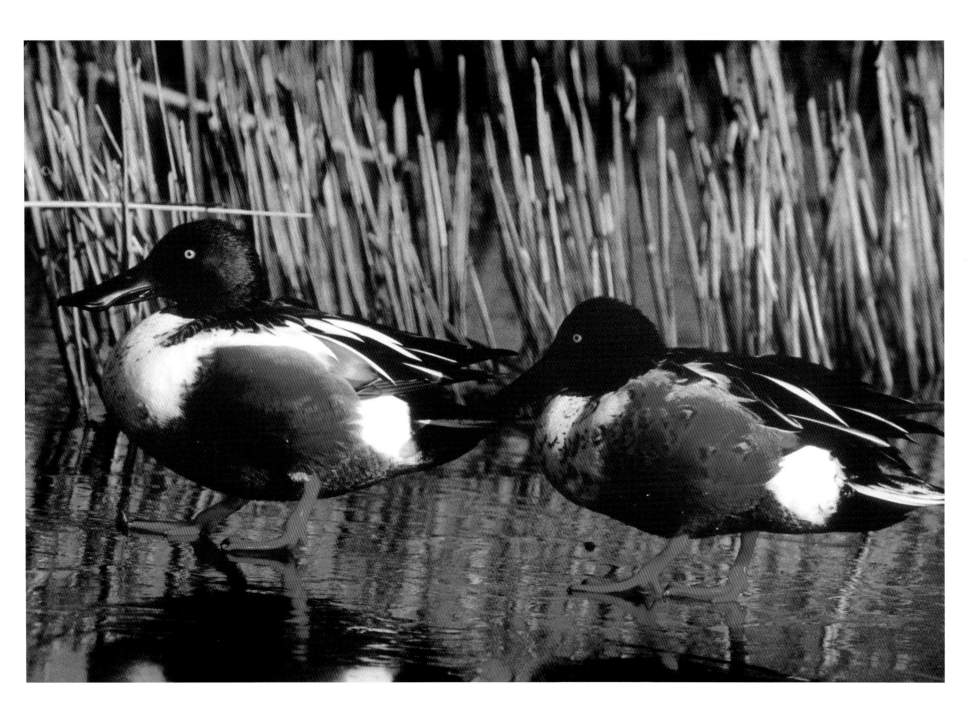

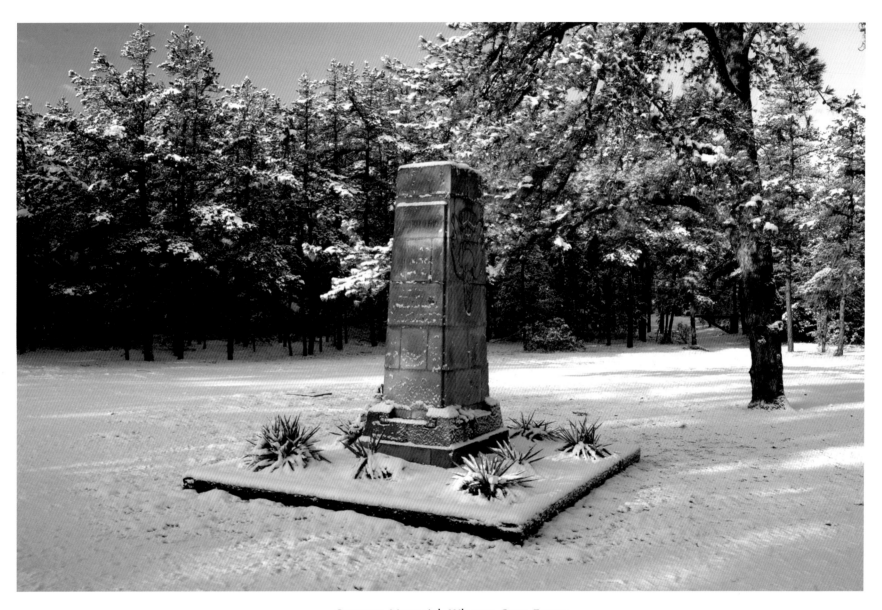

Carranza Memorial, Wharton State Forest

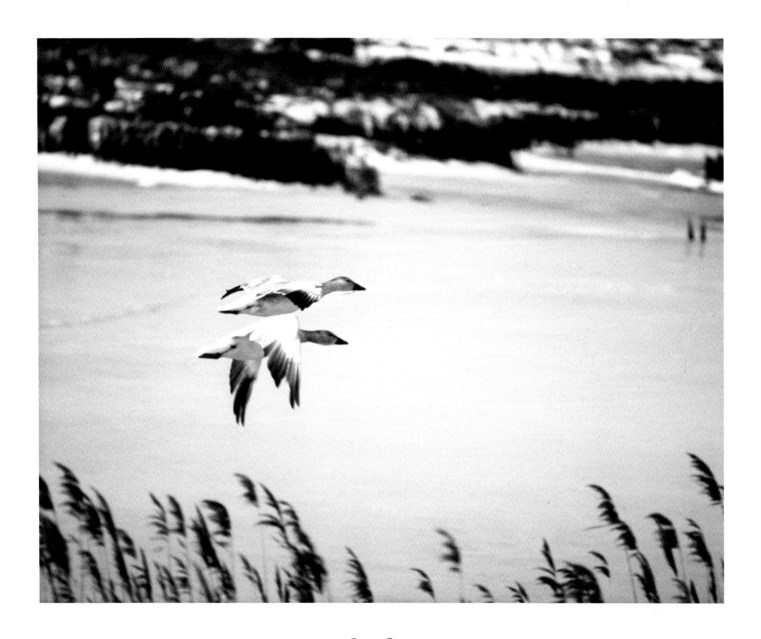

Snow Geese

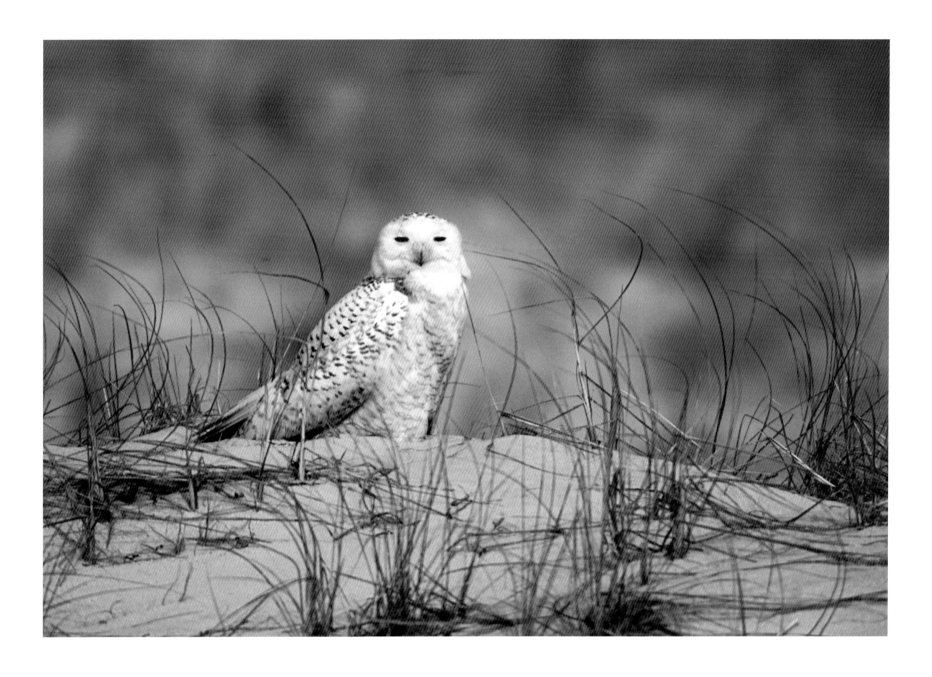

Snowy Owl

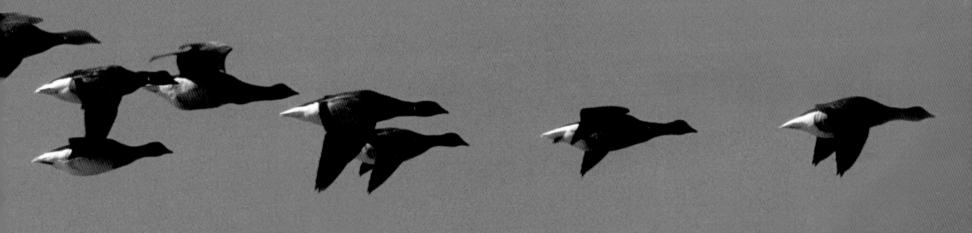

EDWIN B. FORSYTHE NATIONAL WILDLIFE REFUGE

Brigantine

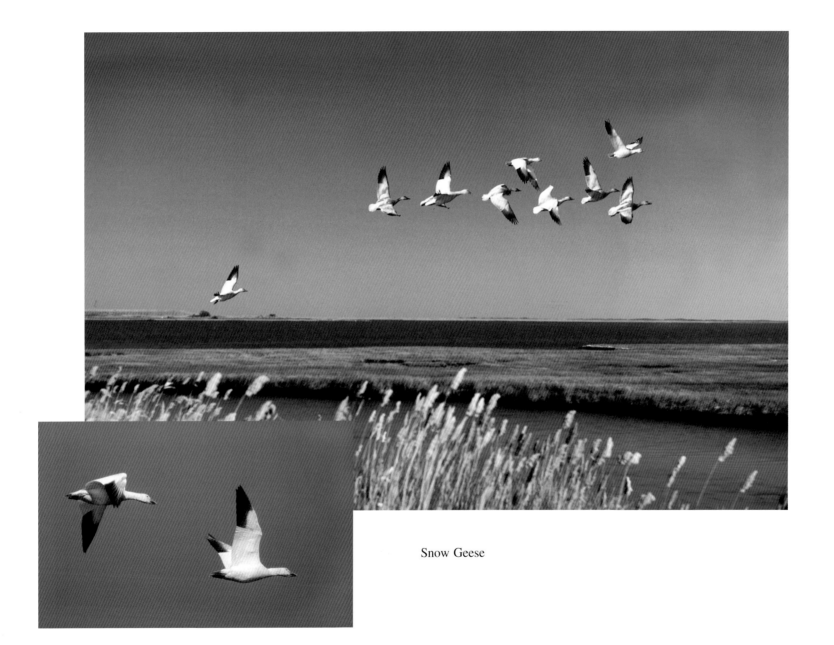

Snow Geese

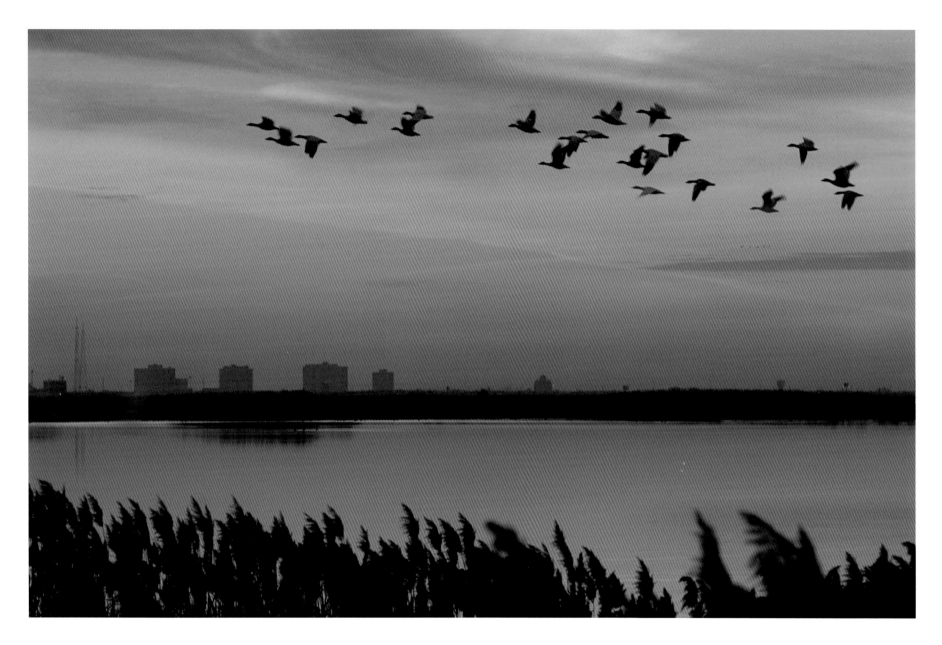

Snow Geese over the Atlantic City skyline

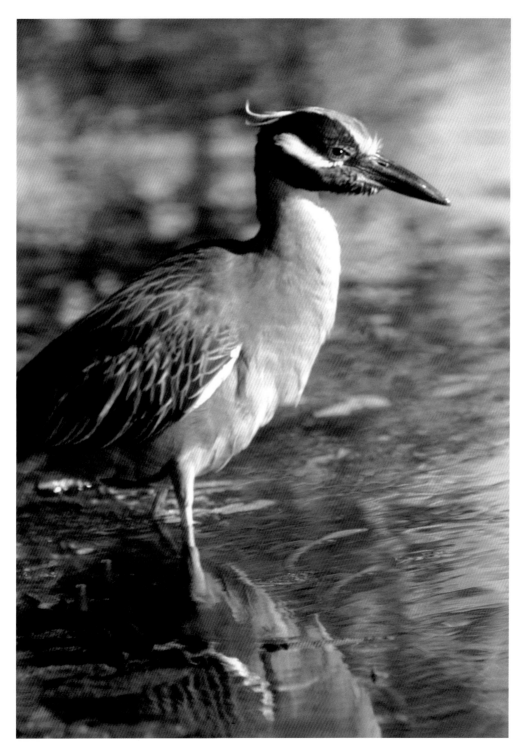

Yellow-crowned Night Heron,
threatened species

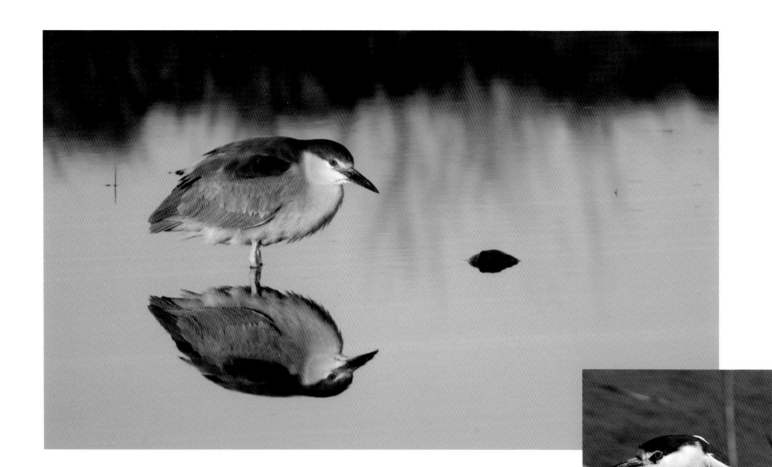

Black-crowned Night Heron, threatened species

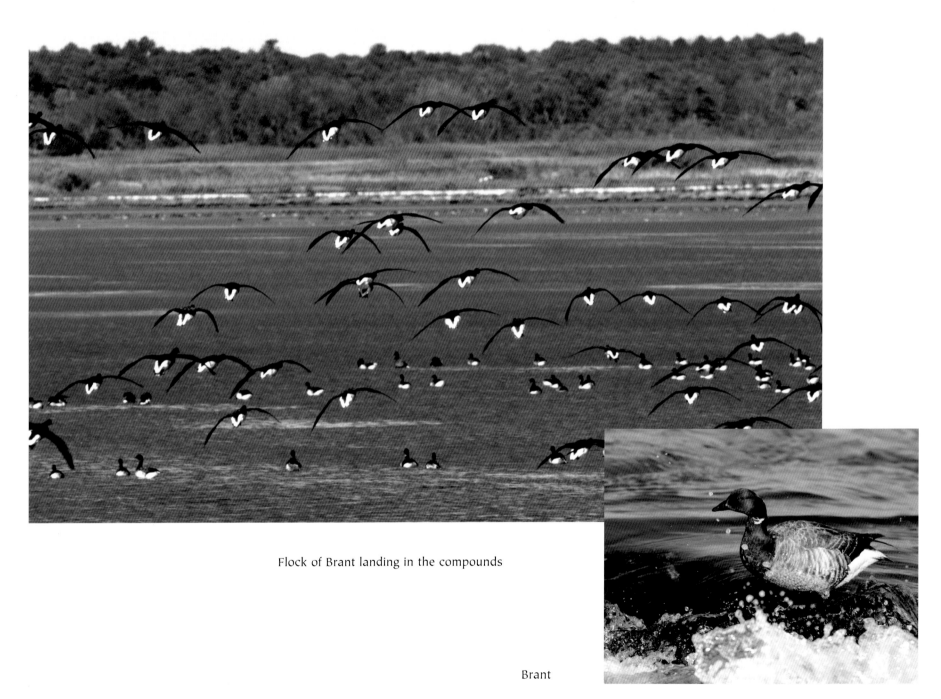

Flock of Brant landing in the compounds

Brant

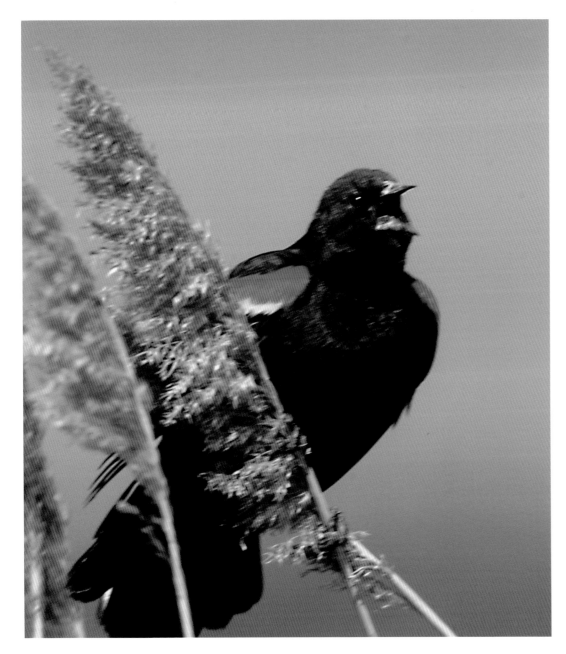

Red-winged Blackbird

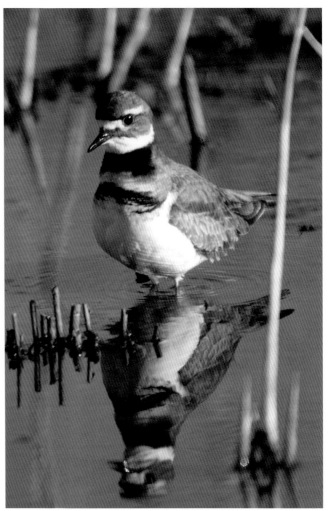

Killdeer

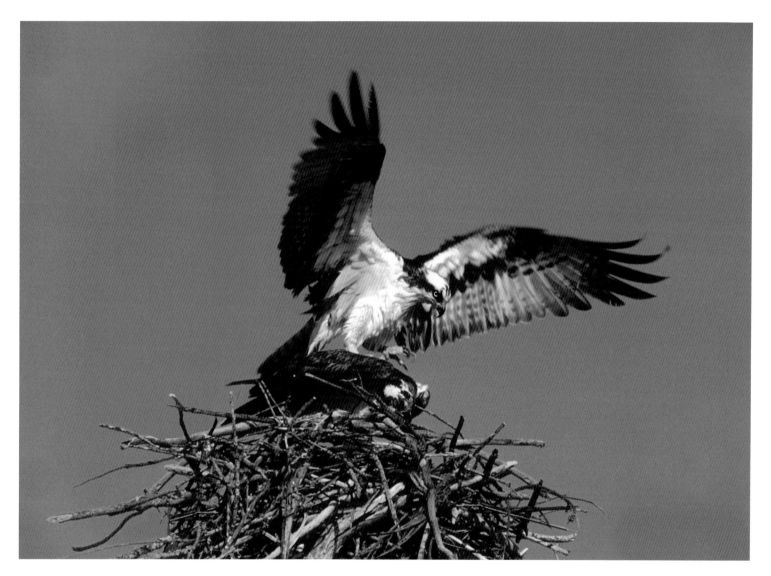

Osprey mating

Osprey on the nest (right)

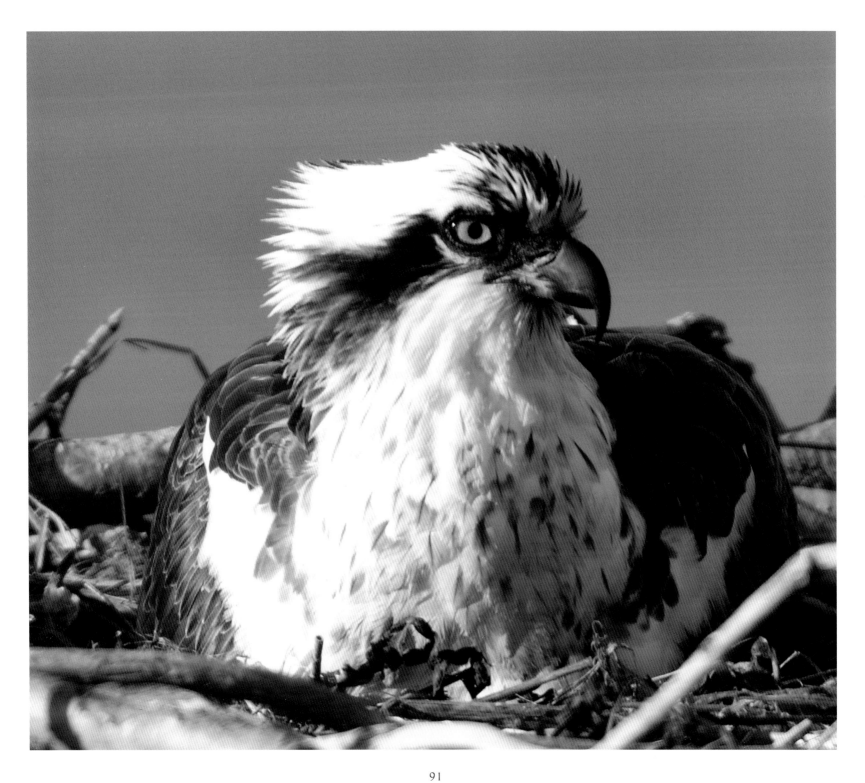

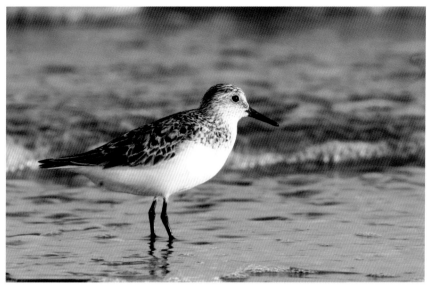

Semipalmated Sandpiper

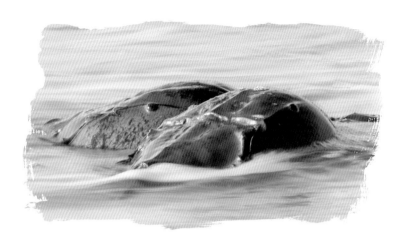

Horseshoe Crabs

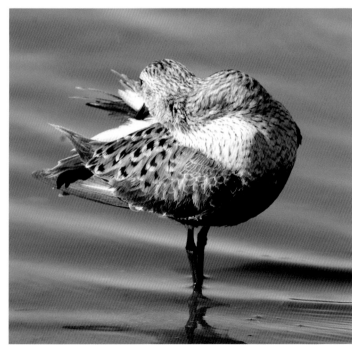

Dunlin

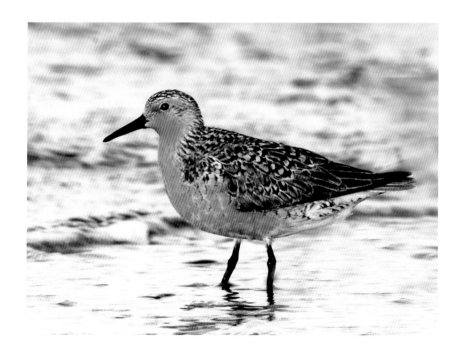

Red Knot

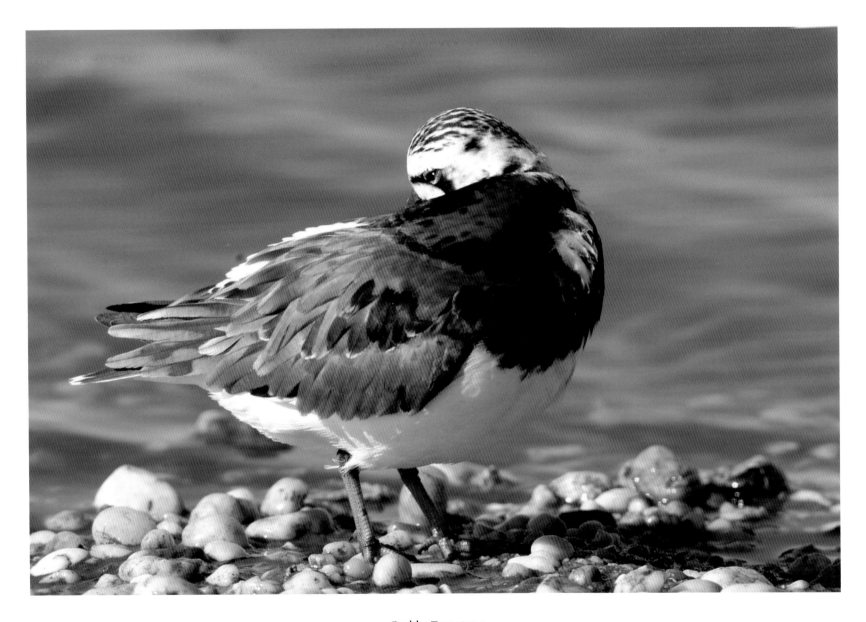

Ruddy Turnstone

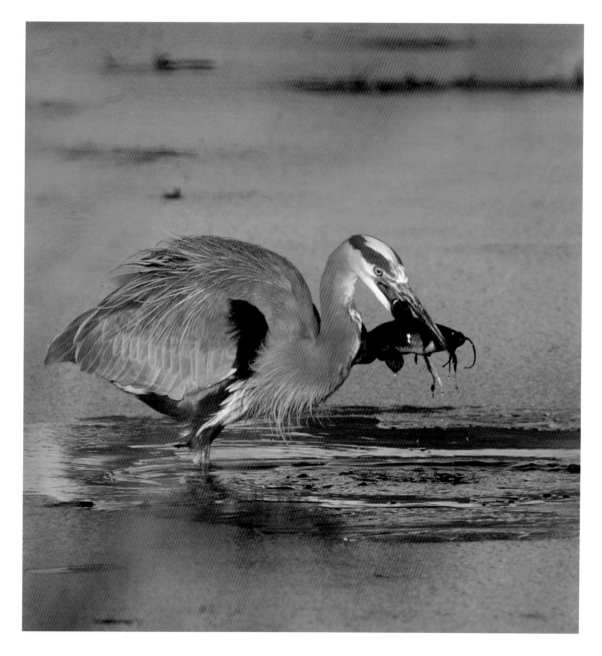

Great Blue Heron
Ice fishing

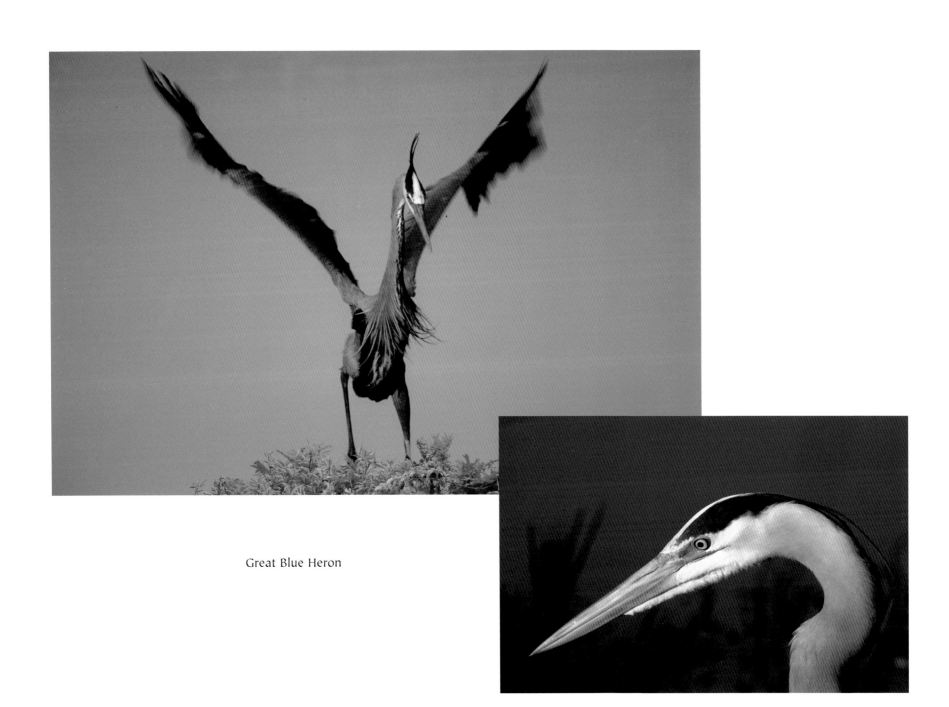

Great Blue Heron

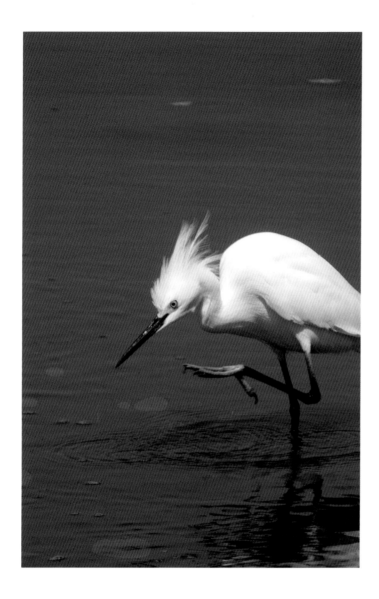

Snowy Egrets

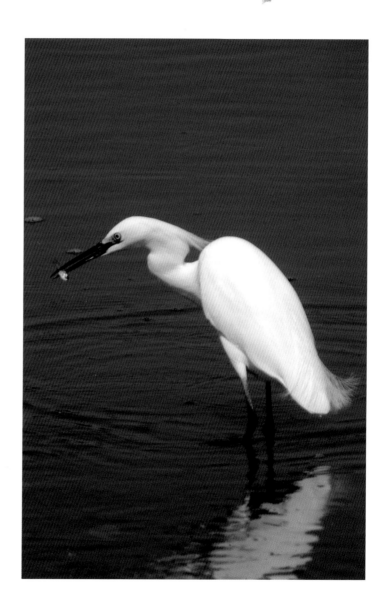

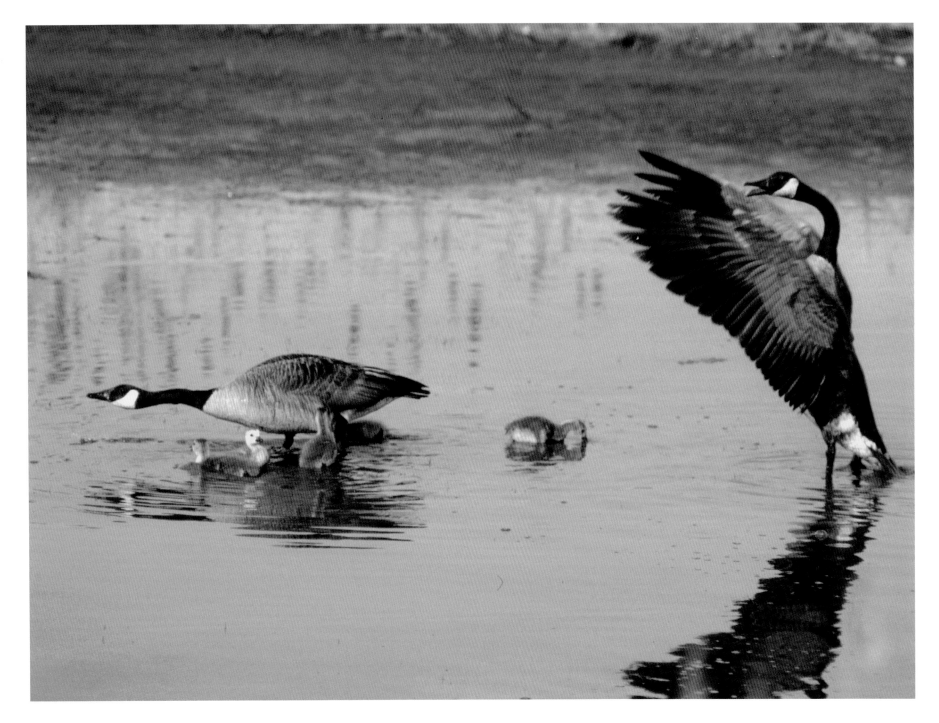

Canada Geese defending their young

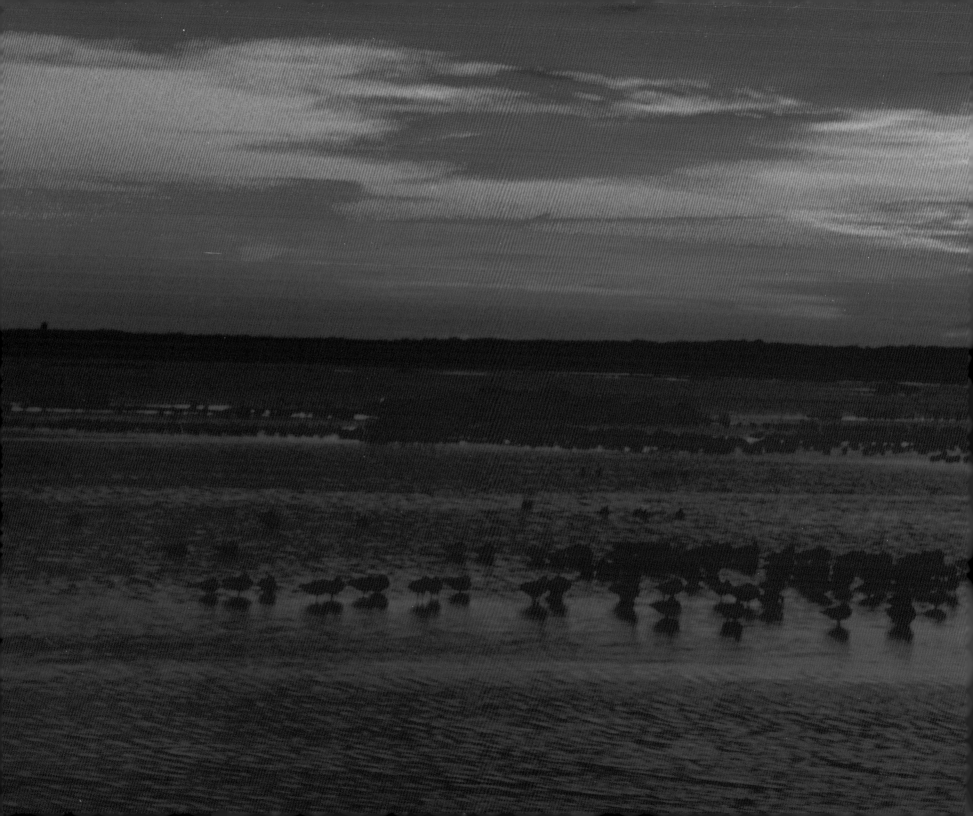

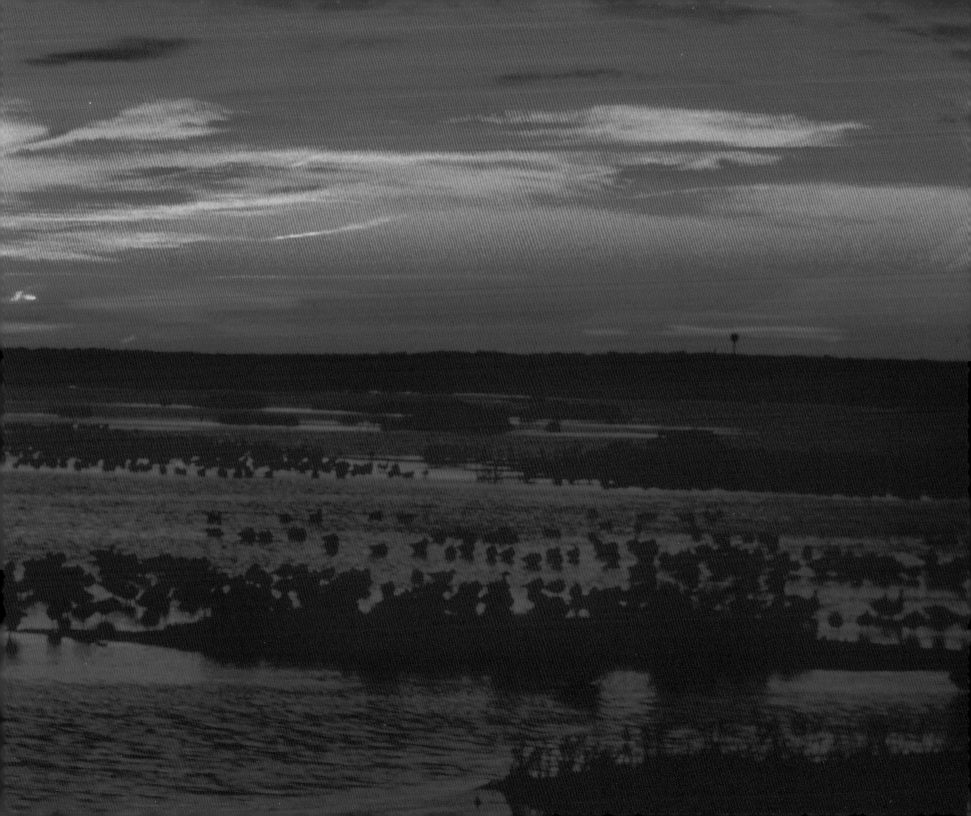

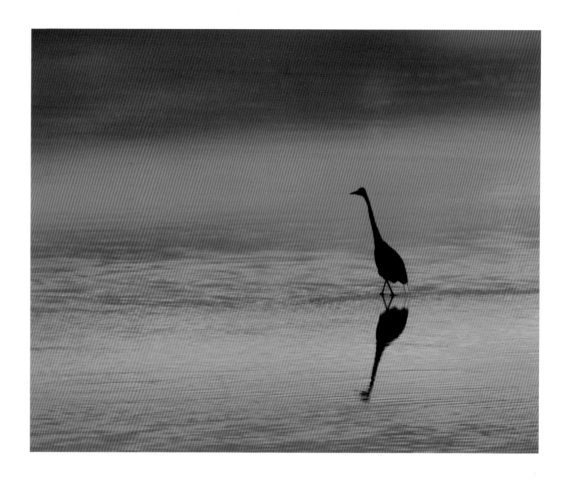

Egret at sunset

Chapter Images

Spring, Mountain-laurel
Summer, Water Lillies
Autumn, Colors at Whitesbog
Winter, Wharton State Forest
Edwin B. Forsythe National Wildlife Refuge, Brant in flight

Other images

Page 1, Tufted Titmouse
Page 2, Turk's-Cap Lily
Page 4, Red-winged Blackbird
Page 5, Great Egret in flight
Page 6, The road to "You Guess"
Page 8, Red Fox
Page 10, Bluebird nest
Previous Pages 98-99, Sunset at Brigantine

Index

* Controlled Photo Shoot